looking at

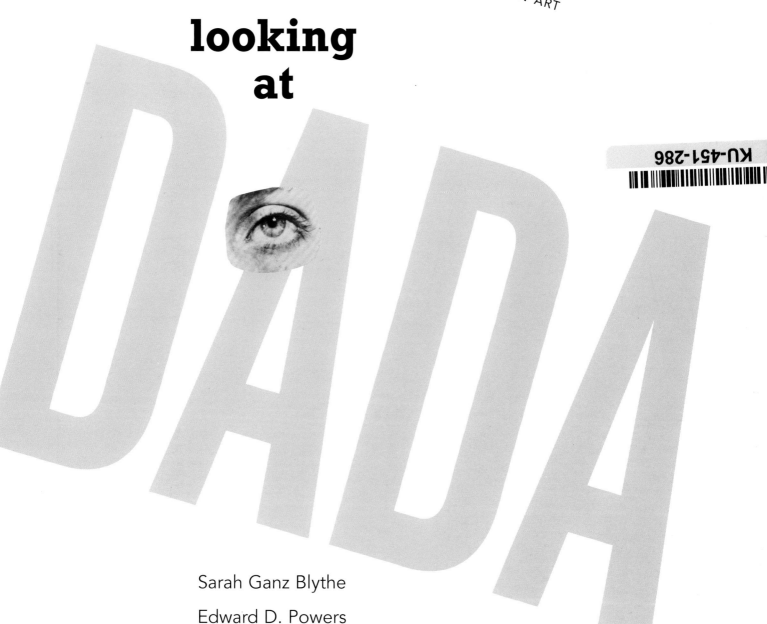

Sarah Ganz Blythe

Edward D. Powers

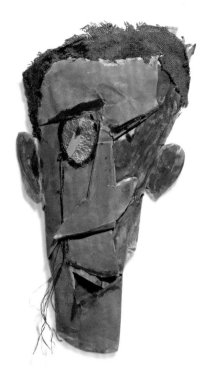

Some Enchanted EVENings

What is Dada? This question was asked persistently by both adherents and audiences of Dada's unorthodox performances and works of art, which seemed to defy everything that art was thought to be about. "Dada is irony," "Dada is politics," "Dada will kick you in the behind," claimed its participants. First emerging in Zurich and subsequently taken up in other cities, notably Berlin, New York, and Paris, Dada was not a style but rather the practice—with a variety of strategies—of undermining expectations and shocking the viewer into questioning blindly accepted, fundamentally repressive conventions and structures of all kinds.

On February 5, 1916, in Zurich, an unorthodox fusion of theatrical performance, poetry reading, and art exhibition was presented in a small nightclub, the Cabaret Voltaire. "On the stage of a gaudy, motley, overcrowded tavern there are several weird and peculiar figures.... Total pandemonium. The people around us are shouting, laughing, and gesticulating. Our replies are sighs of love, volleys of hiccups, poems, moos, and miaowing of medieval Bruitists....We were given the honorary title of Nihilists." So French artist Jean (Hans) Arp described the performances. The choice of name for the Dadaists' nightclub was a significant one. The seventeenth-century French Enlightenment philosopher Voltaire had demonstrated an irreverence for decorum and questioned accepted values in his attacks on established institutions and patterns of thought. This resonated with the disillusionment World War I had ignited among pacifists and political refugees like Hugo Ball, Hermann Hesse, James Joyce, Rainer Maria Rilke, Carl Jung, and Vladimir Lenin, who sought refuge from war-torn Europe in the neutral Swiss city. "Our cabaret is a gesture," Swiss poet and performer Ball wrote in a diary entry later that year. "Every word that is spoken and sung here says at least this one thing: that this humiliating age has not succeeded in winning our respect."

The artworks created by the Dadaists for their stage performances at the Cabaret

3

MARCEL JANCO. Romanian, 1895–1984
UNTITLED (MASK, PORTRAIT OF TZARA). 1919
Paper, board, burlap, ink, and gouache,
21⅝ x 9¹³⁄₁₆ x 2¾" (55 x 25 x 7 cm)
Centre Pompidou, Musée national d'art moderne-
Centre de création industrielle, Paris. Gift of the artist

Voltaire were highly eclectic and improvised, often composed of simple, raw materials. Marcel Janco's mask portrait of poet and avant-gardist Tristan Tzara (p. 3), for example, is fabricated from paper, board, burlap, ink, and gouache. Like a caricature it merely evokes the narrow face, pointed chin, and round spectacles of the ringleader of the Zurich Dada group. "We were all there when Janco arrived with his masks, and everyone immediately put one on," Ball's May 24 diary entry records. "Then something strange happened. Not only did the mask immediately call for a costume; it also demanded a quite definite, passionate gesture, bordering on madness. Although we could not have imagined it five minutes earlier, we were walking around with most bizarre movements, festooned and draped with impossible objects, each one of us trying to outdo the other in inventiveness."

Intended to be handled, worn, and seen in motion, the masks disrupted socialized behavior. Masks, particularly those from Africa, had been a fascination of vanguard artists for the past decade. Their radical simplifications and stylizations, along with the alternative to predictable Western practices they suggested, inspired artists ranging from Pablo Picasso in Paris to Ernst Ludwig Kirchner in Berlin. The Cabaret Voltaire was occasionally given over to soirées featuring African-inspired music, poetry, and dance performed with Janco's masks. These temporary, ephemeral "faces" provided performers with a facade behind which to articulate otherwise inexpressible emotions. "The motive power of these masks was irresistibly conveyed to us…. What fascinates us all about the masks is that they

represent not human characters and passions, but…passions that are larger than life. The horror of our time, the paralyzing background of events, is made visible."

This "paralyzing background of events" included the Germans "bleeding the French army to death" at Verdun, an assault on humanity answered by the Dadaists with an all-out war against the social, political, economic, and cultural structures that permitted and supported such violence: nationalist politics, bourgeois values, communicative functions of language, pious social mores. In his highly irreverent *Manifeste de M. Antipyrine*, of 1916, Tzara declared: "…Dada remains within the framework of European weaknesses, it's still shit, but from now on we want to shit in different colors so as to adorn the zoo of art with all the flags of all the consulates…."

Whether the word Dada was first randomly chosen by stabbing a knife into a dictionary (as the story goes) or was consciously selected for the variety of its connotations in different languages (hobbyhorse, children's nurse, "yes, yes"), the Dada movement came to coalesce around a set of strategies—including collage, montage, the Readymade, chance—that have become fundamental to the practice of modern art today.

In Berlin, on June 30, 1920, the First International Dada Fair opened. A photograph taken on the occasion shows key Berlin Dada players, including Raoul Hausmann, Hannah Höch, George Grosz, and John Heartfield, posed among their works of art (p. 5, left). An effigy of a German military officer in full uniform with a pig's head, satirically titled *Prussian*

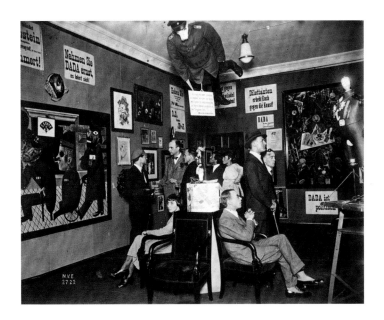

Archangel, hovers above a gallery saturated with texts and images raging against the recently ended war and its profound impact on Germany. Slogans provided unorthodox captions to drive home the point: "Dada is political"; "Dadaist man is the radical opponent of exploitation"; "Dada is fighting on the side of the revolutionary proletariat"; "Down with art, down with bourgeois intellectualism"; "Art is dead"; "DADA is the voluntary destruction of the bourgeois world of ideas." Dada's Berlin incarnation was fraught with anger ignited by the particularly painful social and political realities of a vanquished Germany. Richard Huelsenbeck, who had left neutral Zurich for war-torn Berlin in 1917, recalled, "There is a difference between sitting quietly in Switzerland and bedding down on a volcano, as we did in Berlin." Works of art like Otto Dix's *Skat Players—Card Playing War Cripples* (1920, plate 24) and Grosz's *"The Convict": Monteur John Heartfield after Franz Jung's Attempt to Get Him Up on His Feet* (also known as *The Engineer Heartfield*) (1920, plate 25) featured bodies invaded by mechanical elements and prosthetic devices, a gruesome reality that pervaded everyday street life.

Photomontage, the technique of making a picture by combining photomechanically reproduced images, often with text and other graphic elements, provided the Berlin Dadaists with a means of reconstituting bits of the "real" clipped from the mass media into fractured, composite pictures of a world turned upside down. Labeled as fellow artist Grosz, Hausmann's "art critic" (above) stands before one of his trademark poster poems. The figure is cut from a magazine image, as are his suit, shoes, lady companion, banknote, and sharpened pencil with which he is armed and ready to wage war against the art world and the world of commerce alike. Hausmann wrote that photomontage expressed the Berlin Dadaist's "aversion at playing the artist…thinking of ourselves as engineers (hence our preference for workingmen's overalls) we meant to construct, to assemble [*montieren*] our works."

In Berlin, Dada was a movement articulated through works of art, and an attitude—or way of behaving—that was branded and publicized on the streets and in galleries. Prior to the Fair's opening, the word dada infiltrated street culture via slogans printed on stickers pasted throughout Berlin: "Dada kicks you in

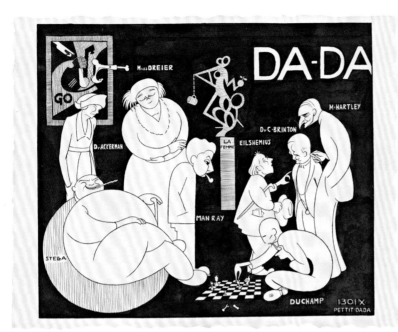

the behind and you like it"; "Come to Dada if you like to be embraced and embarrassed"; "Dada, Dada *über alles.*" The press described the Fair as "The Great Monster Dada Show," and expressed outrage at the Dadaists' project: "These individuals spend their time making pathetic trivia from rags, debris and rubbish. Rarely has such a decadent group, so totally void of ability or of serious intention, so audaciously dared to step before the public as the Dadaists have done here."

In New York, on April 1, 1921, an evening devoted to the ever-compelling "What is Dada?" question was hosted by Katherine Dreier, a major art collector and friend of French artist Marcel Duchamp, at the Société Anonyme, a Manhattan gallery devoted to modern art. The cartoonist Richard Boix recorded those in attendance, giving each a carefully labeled caricature (above). At center left Dreier presides over the assembly, arms folded, accompanied by retired philosophy professor Phyllis Ackerman. Ackerman appears gaunt and withdrawn in contrast to Joseph Stella, the Italian-American Futurist painter in the foreground, who is seated in a presumably modernist chair. He unwisely looks away from the game of chess Duchamp diligently plays with him—and undoubtedly won—while seated cross-legged on the floor. The American painter and photographer Man Ray sullenly looks on, pipe lodged between his teeth. To the right, a group of men gathered in ascending height include the American painter Louis Michel Eilshemius, the art critic Christian Brinton, and the American modernist painter Marsden Hartley, who had been invited to address the assembly on the pressing question. This group portrait includes many whose association with Dada was tenuous, skeptical, questioning; and, like the staged publicity shot of the Berlin Dada Fair, (p. 5, left) it depicts a community that drew together under Dada, in this case to question, rather than to promote, the movement itself.

RICHARD BOIX. American, twentieth century
DA-DA (NEW YORK DADA GROUP). 1921
Ink on paper, 11 1/4 x 14 1/2" (28.6 x 36.8 cm)
The Museum of Modern Art, New York. Katherine S. Dreier Bequest

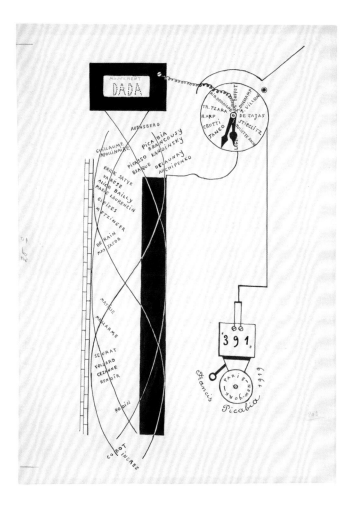

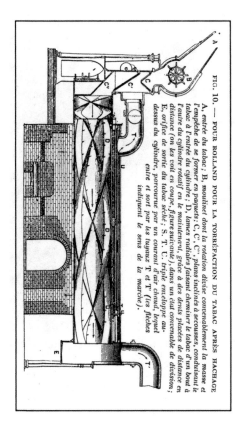

"'Dada' Will Get You If You Don't Watch Out: It Is on the Way Here" threatened the headline of Margery Rex's report on the event in the *New York Evening Journal*. She had asked some of those in attendance to define Dada: "Dada is irony," offered Dreier; Dada is "nothing," Duchamp cryptically added; Dada is "having a good time," suggested Stella; Dada is "a state of mind," said Man Ray. Such quotes hinted that something rather beguiling and perhaps naughty was on the way. The first rumblings of Dada had actually reached New York six years earlier, in 1915, announced by the arrival of several European expatriates, including Francis Picabia and Duchamp who, like those who had fled to

Zurich, sought refuge from the war. Although its very existence is unimaginable without the catalytic presence of the Europeans, Dada in New York, at a considerable distance from the trenches, was less overtly political than its Berlin iteration. New York Dada directed its energies toward challenging accepted notions of art and the tradition of oil painting, most notably by designating preexisting mass-produced objects—so-called "Readymades"—art and by using the playful language of puns, offering humor and simultaneous meanings. As Hartley equivocally remarked, Dada would "take away from art its pricelessness and make of it a new and engaging diversion, pastime, even dissipation."

FRANCIS PICABIA. French, 1879–1953
DADA MOVEMENT. 1919
Ink on paper, 20 ⅛ x 14 ¼" (51.1 x 36.2 cm)
The Museum of Modern Art, New York. Purchase

"Four Rolland pour la torréfaction du tabac après hachage"
(Rolland oven for the roasting of tobacco after cutting).
La Science et la Vie (Science and life), no. 42
(December 1918–January 1919), Vol. XV, p. 76. Rotated

In Paris, on February 5, 1920, a year prior to the New York soirée, an event took place at the Salon des Indépendants. Rumored to include an appearance by Charlie Chaplin, the evening drew many hopeful fans, who were irate at being met with a recitation of Dada manifestos instead: "No more painters, no more writers…no more police, no more fatherlands, enough of all these imbecilities, no more, no more, nothing, nothing, nothing." At first glance strange bedfellows, Dada shared with the slapstick of Chaplin and Buster Keaton—not to mention that other American idiom, jazz—the strategy of undoing established models. In the conservative post–World War I cleanup effort, Dada's iteration in Paris aimed to level the noble ideals of advanced societies, including those of the art establishment, that threatened to take firm hold in the postwar "return to order."

Indeed, Picabia's *Dada Movement* (p. 7, left) suggests time was up for the lineage of French artists, who are wired to blow in his pen and ink diagram. The names of artists, composers, writers, collectors, and avant-garde theorists mark the interstices of a jerry-rigged time bomb. Derived from a *Science and Life* illustration (p. 7, right), Picabia took this depiction of an oven used for roasting cut tobacco, rotated it ninety degrees, and stripped it bare. The names of French nineteenth-century artists considered the fathers of modern art— J. A. D. Ingres, Jean-Baptiste Camille Corot, Auguste Rodin, Pierre-Auguste Renoir, Édouard Vuillard, Georges-Pierre Seurat—rise like an electric current, preceding twentieth-century artists such as Henri Matisse, and Cubist painters Jean Metzinger and Albert Gleizes. The list concludes with Walter Arensberg, a New York collector of French art, who channels the "current" into a rectangular zone— an artistic transformer of sorts bearing the name "Movement DADA." A second current with the names of Cubist artists Picasso and Georges Braque runs into this metaphorical converter, feeding into the ticking international Dada circle that includes Janco, Tzara, Duchamp, Arp, and the New York photographer Alfred Stieglitz. A chosen set of abstract artists including Vasily Kandinsky and Constanin Brancusi, led by Picabia, manages to bypass the Dada transformer and is wired directly to the Dada circle or clock. Thus fueled, it will tick and presumably sound the alarm or ignite the bomb that is Dada in New York and Paris through the mouthpiece of Picabia's publication *391*, modeled after Stieglitz's avant-garde journal *291*.

Picabia's drawing was created for the periodical *Anthologie Dada*, published in Zurich in May 1919. The drawing faced a text by Tzara that included the provocative statement "shit was born for the first time …," as if the story of Dada should be told as an irreverent creationist myth. Picabia shuffles the history of modern art to proclaim a group identity for the Dadaists and his key position in it. This is also a group portrait of sorts that plots the subjects' place in the Dada cosmology rather than records their physical attributes. Such a chart seeks to sort out and mark down Dada's players—Who's in? Who's out?—and Dada's place in the evolution of modern art—Where do we come from? Where are we going? Despite Dada's nihilism, it was surprisingly self-conscious of its place in modern art, in constructing and writing its history; self-conscious, as well, about the notion of what is a picture.

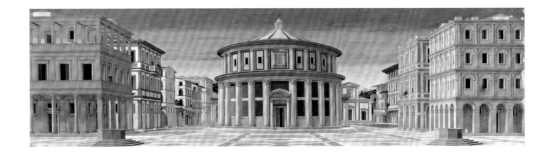

Traditional picture making assumes that an image offers a view onto another world—that a painting, in other words, is like a window. Renaissance artists were compelled to render their images as realistically as possible to better transport the viewer to another place perfectly fixed in time, be it a scene from the life of Christ or the depiction of an ideal city (above). Linear perspective created the convincing illusion of three-dimensional space on a two-dimensional plane, while volume was suggested by the modeling of form to register light and dark. Leon Battista Alberti's ideal of the painted image as articulated in *De pictura* (1435–36) was based on a frame that could offer access to the depicted world: "[…On] the surface on which I am going to paint," Alberti wrote, "I draw a rectangle of whatever size I want, which I regard as an open window through which the subject to be painted is seen." With meticulous brushstrokes, artists worked hard to erase all trace of the flat, opaque surface on which they worked, and lure the viewer into a world in which he or she could imaginatively roam. What lay within the frame of a picture was intended to create an illusion and coax the viewer into a suspension of disbelief—a virtual world. To challenge this sacrosanct concept of the picture as window was to defy the very purpose of painting.

When Duchamp wanted to sabotage traditional picture making, he called upon a window to wage his battle. *Fresh Widow* (1920, plate 1) is a small replica of a traditional French window that the artist commissioned from a carpenter in New York. The wood casement is painted turquoise-green, but the glass panes are covered with black leather, the surface of which Duchamp insisted "should be shined every day like shoes." Rather than a view through glass, we are met with complete blackness, and the two small knobs are simple pushpins while the hinges are enticing but useless. Duchamp blacked out Alberti's transparent window, and in doing so he laid bare the conceit of painting and even suggested its antithesis. There is no view, no story, nowhere for the eye to take us.

9

PIERO DELLA FRANCESCA. Italian, c. 1420–92
VIEW OF AN IDEAL CITY. 1490–1500
Panel, 23⅝ x 78¾" (60 x 200 cm)
Galleria Nazionale delle Marche, Urbino, Italy

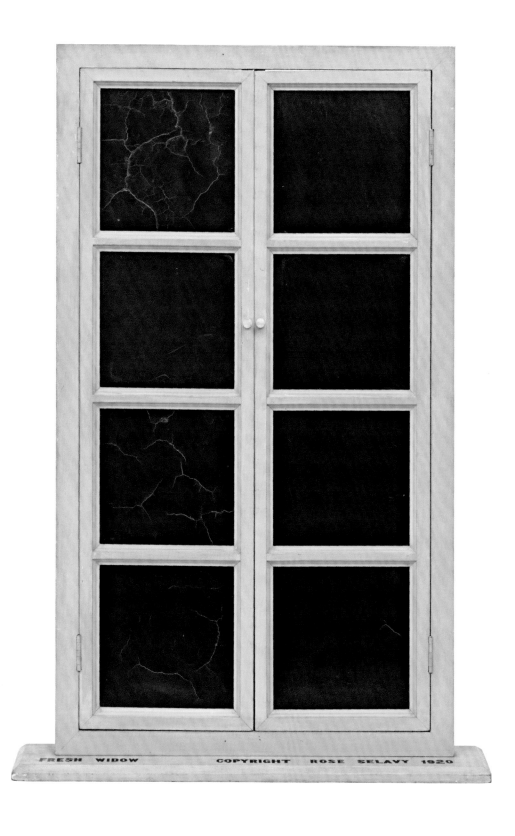

Plate 1
MARCEL DUCHAMP. American, born France. 1887–1968
FRESH WIDOW. 1920
Miniature French window, painted wood frame, and panes of glass
covered with black leather: 30½ x 17⅝" (77.5 x 44.8 cm),
on wood sill: ¾ x 21 x 4" (1.9 x 53.4 x 10.2 cm)
The Museum of Modern Art, New York. Katherine S. Dreier Bequest

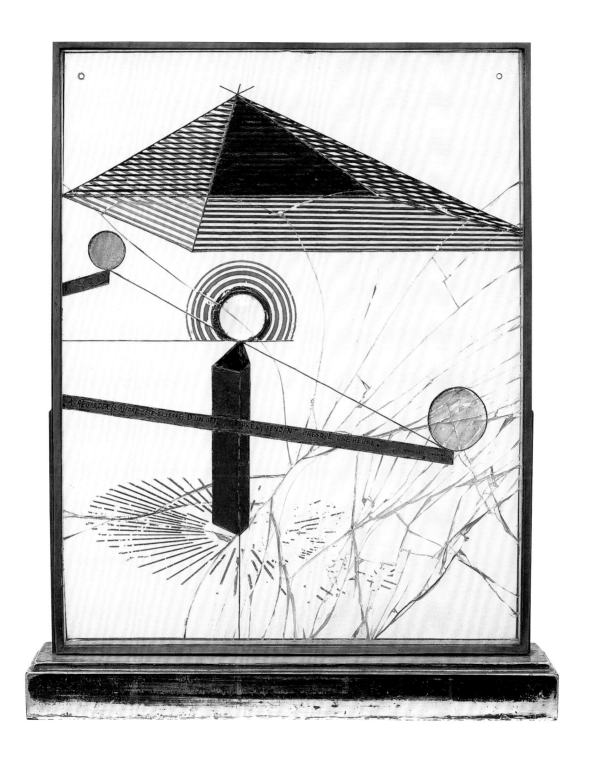

Plate 2
MARCEL DUCHAMP. American, born France. 1887–1968
**TO BE LOOKED AT (FROM THE OTHER SIDE OF THE GLASS) WITH ONE EYE,
CLOSE TO, FOR ALMOST AN HOUR.** 1918
Oil, silver leaf, lead wire, and magnifying lens on glass (cracked): 19 1/2 x 15 5/8 (49.5 x 39.7 cm),
mounted between two panes of glass in a standing metal frame: 20 1/8 x 16 1/4 x 1 1/2" (51 x 41.2 x 3.7 cm),
on painted wood base: 1 7/8 x 17 7/8 x 4 1/2" (4.8 x 45.3 x 11.4 cm); overall height, 22" (55.8 cm)
The Museum of Modern Art, New York. Katherine S. Dreier Bequest

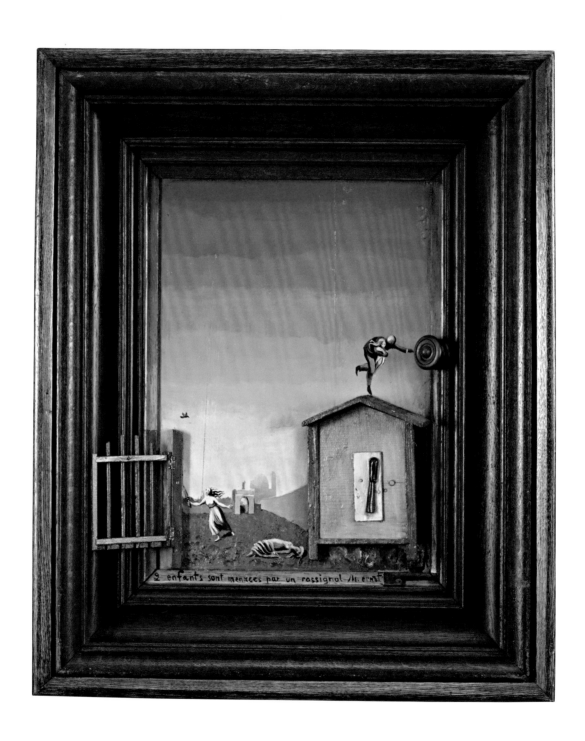

Plate 3
MAX ERNST. French, born Germany. 1891–1976
TWO CHILDREN ARE THREATENED BY A NIGHTINGALE. 1924
Oil on wood with painted wood elements and frame,
27 ½ x 22 ½ x 4 ½" (69.8 x 57.1 x 11.4 cm)
The Museum of Modern Art, New York. Purchase

With black capital letters along the base, Duchamp boldly inscribed the work "Fresh Widow Copyright Rose Sélavy 1920." Turning an inanimate French window into the anthropomorphic "Fresh Widow" was, he felt "an obvious enough pun." The title has been taken to refer to the casualties of World War I (which had recently widowed an astonishing number of women); Duchamp may have also been alluding to his recent abandonment of painting, which historically has been personified as feminine—a mistress or muse, which the artist had now deserted. Having forsaken the traditional practice of creating illusory windows onto other worlds, Duchamp self-effacingly remarked that he was now a "*fenêtrier*," or "window-maker." He departed from traditional notions of individual artistic authorship, further distancing himself from the work by creating the female alter ego Rose Sélavy, a pseudonym with which he signed—or rather copyrighted—this work, and which he would continue to use over the decades. Later, after adding an additional "r" to the name (Rrose), Duchamp's clever punning suggested other meanings: "*Eros, c'est la vie*" (Eros, it is life), as well as "*Arroser la vie*" (Drink to life).

Duchamp depended on language to complete the meaning of his work. As he explained: "I wanted to get away from the physical act of painting. . . . For me the title was very important. . . . I was interested in ideas—not merely visual products. I wanted to put painting once again at the service of the mind." To pun is to play intellectually with words. A pun is trickery of sorts, not unlike the act of deception in which illusionistic painting is involved. *Fresh Widow*, neither a painting with a view nor a functional object, plays upon

and confounds standard expectations and associations: windows typically offer views; texts usually offer clear meaning.

When a work of art ceases to behave according to our expectations, it seems to beg for instructions that explain or at least indicate how we are to relate to it. Words inscribed on an ordinary object can cause it unexpectedly to suggest something other than itself. Words can also specify how a work is "to be looked at." Inscribed in French on a strip of metal glued across the approximate center of a 1918 work on glass by Duchamp are the instructions "To be looked at (from the other side of the glass) with one eye, close to, for almost an hour" (plate 2). The inscription suggests that we look through the glass pane, or lens, mounted between two panes of glass haloed in concentric circles, which appears to teeter atop a truncated obelisk, or prism, that sports rays around its base. This delicate ellipse of silver beams, which Duchamp curiously called the "Oculist Witness," appears to hover perpendicularly to the glass plane. He had a patch of silver applied to the surface that he then meticulously scraped away, leaving the circular patterning in perspective. Hovering at top is the illusion of a squat, three-dimensional pyramid composed of horizontal lines delicately painted in red, yellow, blue, and green. Although Duchamp renounced the optical illusionism of traditional painting, he was intensely interested in the science of optics.

Rather than the illusion of a view onto another world—or the punning negation of it—Duchamp's transparent work frames and distorts whichever space it occupies. Peering through the convex lens "for almost an hour"

is supposed to have a hallucinatory effect, as the view (usually of other people and art in a gallery) is dwarfed, flipped, and otherwise distorted. Playing with painting's traditional construction, Duchamp provided a foreground of calculated shapes, while the background is contingent on where the work of art is placed; what can be seen behind it in the gallery is up to chance. After all, this was a more efficient, economical way of creating an image: "The main point is the subject, the figure," while the background is "tactile space like wallpaper," explained the artist; "all that garbage, I wanted to sweep it away." Duchamp delighted in the fact that the glass shattered while being transported, the jagged cracks further confounding and fragmenting the object's chance encounter with the real world. Rather than offering escape into a story or environment, the environment is framed and focused by the work of art, and its story is ever subject to change, like the physical state of the artwork itself.

While Duchamp leaves the story told by his work up to chance, Max Ernst constructs a story without logic, inviting us into a picture inscribed "Two children are threatened by a nightingale" (1924, plate 3). Ernst noted that the work may have derived from a "fever-vision" he experienced when he had measles at the age of six: "provoked by an imitation-mahogany panel opposite [my] bed, the grooves of the wood taking successively the aspect of an eye, a nose, a bird's head, a *menacing nightingale*, a spinning top, and so on." A prose poem Ernst penned shortly before executing the work, begins, "At nightfall, at the outskirts of the village, two children are threatened by a nightingale."

With its old-fashioned frame and plunging perspective, this work recalls painting's traditional role as portal between this world and another. A red wooden gate affixed to the painted surface opens onto a deceptively pastoral scene dominated by blue sky, with a triumphal arch and domed building in the distance. The female figures in the foreground are painted in grisaille, a restricted palette of blacks, whites, and grays; their vaguely classical robes and phantomlike coloring suggest antique sculptures come alive. One brandishes a small knife, as though fending off the unassuming nightingale at left; another falls limp in a swoon; a man who alights atop the roof carries off a third, his hand outstretched to grab the knob, or "spinning top," fastened to the frame. Like Alice trapped in Wonderland, he desperately reaches out from dream world to real world, turning the knob to fling open the door that is the painted image and flee the nightmarish scene.

While the deep frame and carefully painted landscape lure us into the painting's bizarre world, the items stuck onto the painted panel remain stubbornly rooted in our space. Three-dimensional things and two-dimensional painted illusions of things have been brought into uncomfortably close proximity to one another, both inviting and disrupting our suspension of disbelief. Indeed, belief that a painting is a window onto another world requires a leap of faith, a willingness to be won over by what lies within the frame. This assemblage, like puns or chance, challenges the enchantment of painting, making its usual ploys seem farcical, and trust in the views and stories it offers, gullible.

2.
PIN-ups

Rather than a convincing illusion of "reality" or an otherwise eye-catching imitation of three-dimensional space, the artworks in this section, by Francis Picabia, Hannah Höch, and Kurt Schwitters, consist of actual fragments of the "real world," and are themselves comparable to everyday objects. Picabia's *The Cacodylic Eye* (1921, plate 4), for instance, might be understood as a variation on one of those greeting cards that the entire office signs with clever (and corny) quips—in this case, a "get-well" card signed by Picabia's Dada colleagues on the occasion of his being treated for an eye ailment. Neither is Höch's *Cut with the Kitchen Knife Dada Through the Last Weimar Beer-Belly Cultural Epoch in Germany* (1919, plate 5) a seamless recreation of the real world. In its bulletin-board universe covered with clippings from magazines, heads float free from bodies, moustaches are configured out of wrestlers, and hats consist of locomotive engines with matching earmuffs made of horse-drawn carriages. *Cut with the Kitchen Knife* is a thoroughly multilayered and symbolic world populated by cultural icons and tokens of everyday life inextricably linked to Höch's contemporary experience of post–World War I Weimar Germany. And Schwitters's *Merz Picture 32A (The Cherry Picture)* (1921, plate 6) might be most easily understood as a dysfunctional carpenter's bench—albeit one whose surface the artist has meticulously constructed with layer upon layer of paper and cloth, wood and cork. "I am a painter and I nail my pictures together," Schwitters once declared upon introducing himself to a Dada colleague.

An alternative approach to the picture as window onto another world can be found in the comparably flat surfaces of desktops, studio floors, and bulletin boards—indeed, according to art historian Leo Steinberg, in "any [receptive] surface on which objects are scattered, on which data is entered, on which information may be received, printed, impressed—whether coherently or in confusion." The material reality of these surfaces as gathering places, Steinberg explains, "insist[s] on a radically new orientation, in which the

15

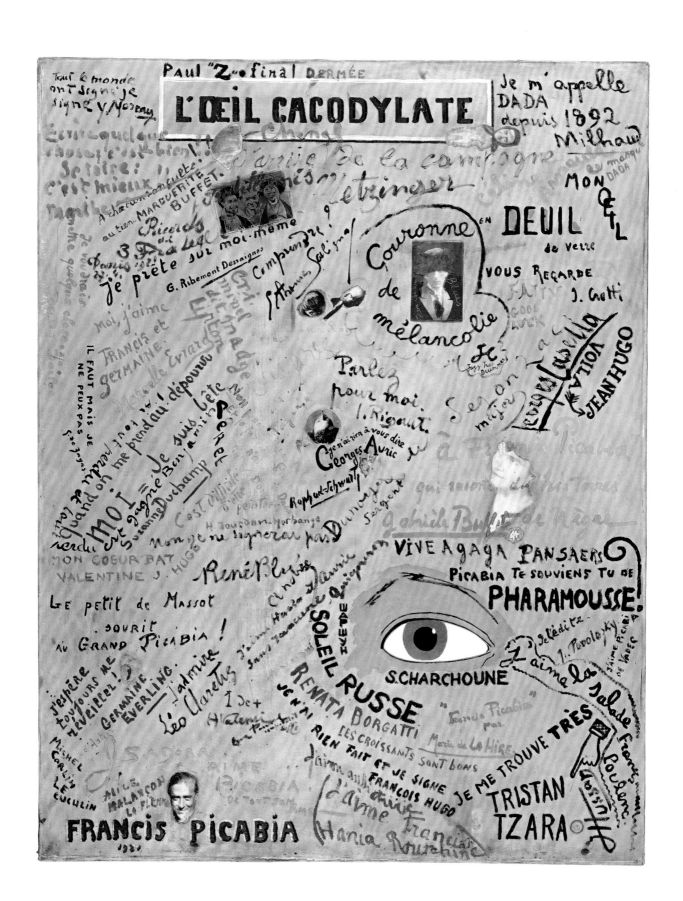

Plate 4
FRANCIS PICABIA. French, 1879–1953
THE CACODYLIC EYE. 1921
Ink, gouache, and collage on canvas, 58 1/2 x 46 1/4" (148.6 x 117.4 cm)
Centre Pompidou, Musée national d'art moderne-Centre de création industrielle, Paris.
Purchase

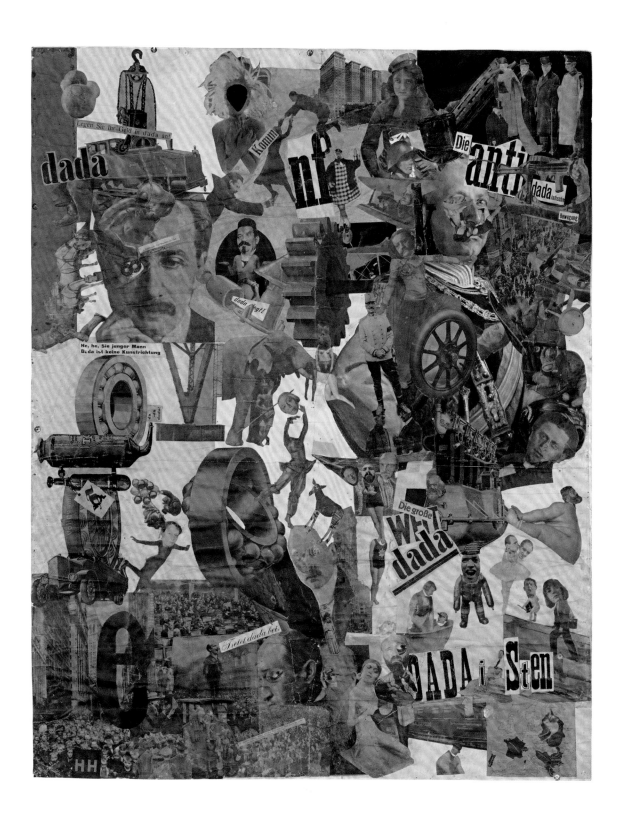

Plate 5
HANNAH HÖCH. German, 1889–1978
CUT WITH THE KITCHEN KNIFE DADA THROUGH THE LAST WEIMAR
BEER-BELLY CULTURAL EPOCH IN GERMANY. 1919
Photomontage and collage with watercolor, 44 7/8 x 35 7/16" (114 x 90 cm)
Staatliche Museen zu Berlin, Nationalgalerie

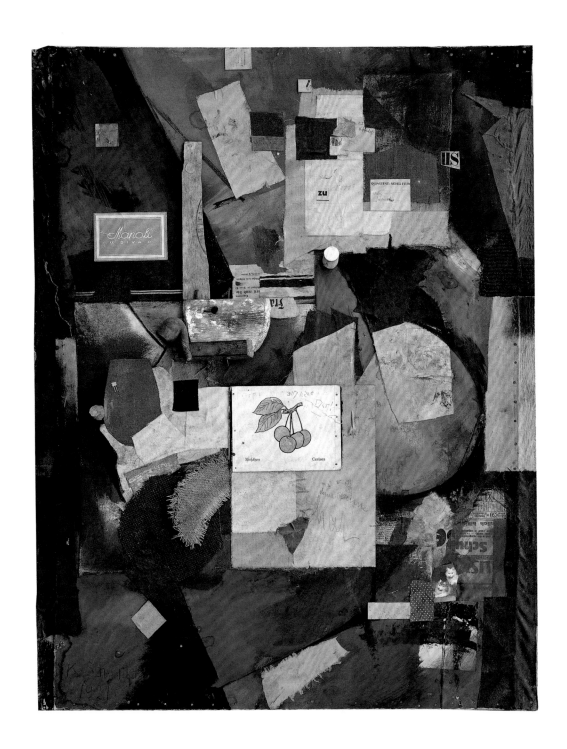

Plate 6
KURT SCHWITTERS. German, 1887–1948
MERZ PICTURE 32A (THE CHERRY PICTURE). 1921
Cut-and-pasted colored and printed papers, cloth, wood, metal,
cork, oil, pencil, and ink on board, 36 1/8 x 27 3/4" (91.8 x 70.5 cm)
The Museum of Modern Art, New York. Mr. and Mrs. A. Atwater Kent, Jr. Fund

painted surface is no longer the analogue of a visual experience of nature but of operational processes." Because these writing or work surfaces are often opaque, they are not glassy gateways to imagery intended to trick the eye but rather solid ground on which all manner of things can actually be accumulated and arranged. The central importance of the artist's process is evident in Picabia's solicitation of the signatures and phrases on the greeting-card-like surface of *The Cacodylic Eye*, Höch's compilation of magazine clippings on the bulletin board–like surface of *Cut with the Kitchen Knife*, and Schwitters's arrangement of diverse materials on the carpenter's-bench-like surface of *The Cherry Picture*. Like bandleaders conducting their orchestras, we might say, these artists are responsible for orchestrating their pictures. Thus Picabia and Höch, especially, make not the slightest effort to conceal—on the contrary, they delight in revealing—the dramatic pauses between elements, for it is in these interstices that the full extent to which the artworks have been orchestrated is truly evident.

The Cacodylic Eye makes obvious the fact that it is a group effort. All the distinct hands that collaborated on the picture, together with the signature phrases they contributed, vary wildly with respect to script, color, orientation, and whether or not cutout imagery was included. Like the Dada movement itself, a heady mix of contradictory and often paradoxical repartee carries the day here, beginning in the upper-left corner with a Dada colleague's oddly equivocal statement: "Everyone signed[,] I sign." Right below, by contrast, the opera singer Marthe Chenal is unequivocal: "Writing something is good!

Shutting up is better!" About halfway down the left edge, written on an upward-slanting diagonal, the poet Benjamin Péret oxymoronically confesses: "I've lost everything and everything lost is gained." In turn, just below and to the right, a colleague sees this oxymoron and raises it a paradox: "No, I will not sign!" To the right of center, equally startling, is a one-two punch: "Speak for me" followed by "I have nothing to say to you." About a third of the way down the left edge, written in green and perpendicular to its neighbors, a half-thought—"I'd like to put something"—immediately follows another—"I have to but I can't." Just above the lower edge, at center, jeweler François Hugo aptly sums up the picture: "I've done nothing and I sign." As for the rest, mixing equal parts piffle and poetry, the chorus perplexingly peals forth: "To everyone his cult! To your own"; "Fatty, Good Luck"; "I like salad"; "Croissants are good."

Traced out in bold shadow typeface at the upper edge, "*Cacodylate* (Cacodylic)" refers to a substance containing methyl and arsenic, a rather toxic medication prescribed for Picabia's eye ailment. But it is not so much the well Picabia's cacodylic solution is poisoning as the wellspring of traditional painting: its surface limpid as water rather than roiling with phrases and photos, signatures and stains—not to mention traditional painting's equally quaint notion of the artist as solitary genius, for which Picabia substitutes a collaborative free-for-all. "Cacodylic" is also the sort of playful, if obscure, term that Dada artists so often incorporated into their artworks. In this sense, its use refers to the art of language and, in turn, the possibility of language as art.

Cut with the Kitchen Knife exemplifies the sort of anti-illusionism in which a dancer's head can float free from her shoulders while her body stands tenuously tethered to the crazy-quilt imagery that surrounds her. Tellingly, the dancer's head, bounced like a beach ball at the picture's center, was cut from a photograph of Käthe Kollwitz—like Höch, among the most renowned German female artists of her day. Although the floating head is not a portrait of Höch, it is nevertheless an emblem of Höch's artistic process, with both the dancer and the artist alike making an art form of juggling fragments. Höch "signed" the picture by affixing a minuscule photograph of her own floating face to the left edge of the map of Europe, in the picture's lower-right corner, and emphasizing the countries in which women had already been, or would soon be, granted suffrage. As Höch scholar Maud Lavin has indicated, the entire surface of *Cut with the Kitchen Knife* is festooned with such "metaphors of liberation" and, in particular, with imagery centering on women's liberation, including the renowned actresses and female artists and dancers who weightlessly pirouette across the surface, while cogs, ball bearings, and wheels of every description echo the dancers' spinning heads and twirling feet as well as the march of progress to the tune of new technology the work suggests.

Cut with the Kitchen Knife brings us full circle from German militarism through the cultural and political figures of Dada to radical shifts in science and technology. Moving clockwise from the upper-right quadrant, a portrait of the deposed German Kaiser, Wilhelm II, dominates. Although possessed of a face only a Dadaist could love—his top

hat too small and his moustache made up of two upturned, interlocked wrestlers—the "marquis" written across his forehead emphasizes his "antidada" worldview. In the lower-right quadrant, by contrast, Höch has brought together many of the cultural and political icons that make up "the great Dada world" ("*Die große Welt dada*"), including her closest Dada colleague, Raoul Hausmann, dressed for deep-sea diving yet sporting a Karl Marx "feather" in his capacious cap. In the lower-left quadrant are other figures sympathetic to the Dada cause, and at their center stands a revolutionary protagonist from whose mouth issues the imperative "Join Dada" ("*Tretet dada bei*"). The upper-left quadrant is dominated by Albert Einstein's brooding visage, framed by the epochal passage of a nineteenth-century horse-drawn carriage to a twentieth-century locomotive engine (which he sports like a crown), perhaps hinting at the brave new world inaugurated by the publication of his special theory of relativity, in 1905. Yet, while buoyed by new technologies, urban life is no less suffocated by throngs of humanity. In the upper-right quadrant we confront urban high-rise buildings and unemployment lines, and in the lower left, multiplying crowds assembled for every purpose and occasion.

Like *Cut with the Kitchen Knife*, *The Cherry Picture* has all it can do to juggle its fragmentary and floating imagery. Its shape is rectangular, as are many of the elements covering its surface. Just as these individual elements echo the picture's overall format, the rectangular groups into which Schwitters arranges this imagery yield still more rectangular echoes, contributing to the picture's overall effect of multilayered planes within

planes. Even the work's surface appears to be riven from within: a lighter-colored "foreground" consisting of scraps of paper and cloth, bits of wood, and corks—one of which is protuberantly poised just above and to the right of center (and apparently threatening to poke us in the eye)—buoyed by a darker-colored "background" painted in deep-sea blues and foam greens. Other painted passages, especially the tans and darker browns along the upper edge, at center, imperceptibly make the transition from the "near" of real things to the "far" of painted ones. Lighter colors tend to project and darker colors to recede, so you would think this is all the stuff of illusion; but it is an illusion of an illusion, for here lighter components are in actuality often massed above darker ones.

Like Höch's headless dancer, Schwitters's kitschy illustration of cherries is a form of self-reference. The German word "*Kirschen*" (cherries) is very close to the diminutive form of the artist's name, "*Kurtchen*" (little Kurt); as a result, the cherries are something of an artistic signature. Moreover, just above the cherries, the artist has penciled in an ungrammatical German sentence, "*Ich liebe dir!*" (I love she!). For Schwitters, there can only be one "she" addressed in this way— "Anna Blume" (Anna Flower), the subject of his mock love poems. Here, Schwitters provides us with a key of sorts to his fundamental principles of artistic construction, based on natural growth—but of unnatural substances (like the ripening of kitschy cherries, or the blossoming of a woman-flower that is really neither woman nor flower)—and individual subjectivity (as in the eccentric grammar of Schwitters's declaration of love). *The Cherry Picture* is perfectly poised between corresponding states of tension and equilibrium. For even as Schwitters insists on the material variety and reality of each of the work's individual elements, he denies them any sense of uniqueness or wholeness, subordinating them to the picture's overall format. This is the essence of the series to which *The Cherry Picture* belongs—the so-called "*Merz*" series, a term Schwitters derived from the second syllable of the German word "*kommerz*" (commerce). In both the *Merz* pictures and the commerce of everyday life, impersonal fragments are common currency, and only through their exchange do they come to life.

Like the fragments that compose them, at times the three artworks in this section overlap and at others they markedly diverge. Picabia's collage is literally a group effort, while Höch's and Schwitters's are individual ones, although incorporating elements made by hands other than the artists' own. *Cut with the Kitchen Knife* wears its political message on its sleeve, while the politics of *The Cherry Picture* is more subtle and less specific. Furthermore, *The Cherry Picture* celebrates the orderly, balanced development of its surface no less than *The Cacodylic Eye* revels in its very anarchy, with *Cut with the Kitchen Knife* falling somewhere in between. Notwithstanding these differences, around 1920 all three artists were essentially of one mind with respect to what a picture is—and is not.

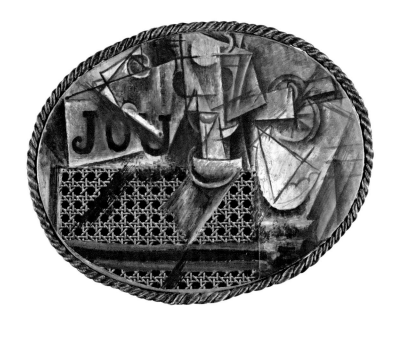

3.
MoNkEy
in the mirror

The picture as window onto another world was something of a mainstay in the Dada artists' critique of art, for which they substituted everything but the kitchen sink—including broken windows and blacked-out ones, doors to nowhere, and anti-illusionist pictures running the gamut from greeting-card- and bulletin-board-like artworks to ersatz carpenter's benches. A significant component of their pictorial practice, however, had already been established by 1912, when Picasso had begun gluing newspaper fragments and decorator's materials—such as fake-wood-grain paper and chair-caning-patterned oilcloth—to the surfaces of his pictures and, together with his Cubist comrade Braque, introduced the art of collage. Derived from the French word *coller* (to glue), collage refers to pictures in which the artist has either literally glued or otherwise affixed all manner of objects to the artwork's surface.

More likely to recall the overcrowded surfaces of café tables than glassy gateways to the beyond, certain of Picasso's collages even go so far as to merge the vertical plane of illusionism—a picture—with the horizontal plane of reality—a table. As art historian Christine Poggi further suggests, there is an etymological relationship between the French words "*tableau*" (picture) and "*table*" (table). (On pictures as gathering places for real objects, see pp. 15–21.) Most famously, on the surface of Picasso's 1912 *Still Life with Chair Caning* (above), the patterned oilcloth, which creates the illusion of the collage's being made with real chair caning, suggests both an illusionist window *and* a real table, as if the viewer were seeing through a glass tabletop to the caning of a chair below. The patterned surface is thus a part of the "real" world, yet one which in reality is fake. Picasso's sleight of hand, producing a teeming-with-clutter yet gravity-defying tabletop he could hang on a wall, is an elegant alternative to the picture as window (why not a picture as tabletop?). It is also a straightforward means of asking why an artist would choose to paint or draw ("represent") something on the surface of a picture that he can simply glue on ("present") instead.

PABLO PICASSO. Spanish, 1881–1973
STILL LIFE WITH CHAIR CANING. 1912
Oil on oilcloth over canvas edged with rope,
11 7/16 x 14 9/16" (29 x 37 cm)
Musée Picasso, Paris

As if in a game of one-upmanship, Picabia at first wanted to attach to the surface of *Still Lifes: Portrait of Rembrandt. Portrait of Cézanne. Portrait of Renoir* (1920, plate 7) not the toy monkey we see here, but a real one. Picabia's use of a vertical support for the fake monkey he used instead makes a monkey out of Picasso's understanding of the illusionism of vertical windows as compared to the reality of horizontal tabletops (as does the simple fact of making a toy-monkey collage in the first place). In a sense, Picabia raised the stakes of Picasso's game by drawing a distinctly Dada analogy between the mimicry of monkeys, the illusionism of paintings, and the absurdity of painters.

With its left hand grasping its tail, which has been cunningly passed between its legs, and its right hand bidding us a vulgar, open-palm adieu, Picabia's toy is certainly not G-rated (in French, the word for tail—"*queue*"— is also slang for penis). Yet, inasmuch as the picture purports to be a portrait of three master painters, perhaps Picabia's toy is merely aping (it is certainly pointing its tail at) Renoir, who once claimed that he painted with his "*queue.*" The inscription with which Picabia "frames" his picture only exacerbates the situation. Most obviously, it pokes fun at two of the time-honored genres of painting: the still life ("*nature morte*") and the portrait ("*portrait*"). After all, what could possibly be more "still" than a toy monkey mounted on a backboard? And given portraiture's traditional claim that it is like a mirror held up to the sitter, why not replace the mimicry of a mirror with the equal talents of a monkey? The inscription accuses three of art history's masters of themselves aping nature, and producing not so much *still life*, but—rather more provocatively—*dead nature* (*nature morte*'s literal translation). For Picabia, then, to imitate nature is, effectively, to kill it.

Picabia's toy is the one Dada stone that he deftly aims at two respected genres of painting—along with three of its celebrated masters. But if these three painters are the "victims" of Picabia's pictorial prank, they are also the "frame" with which the artist assures us of what is *not* to be found within. Not only was Rembrandt one of the most prolific portrait (and, especially, self-portrait) painters in art history, he was also one of the most psychologically penetrating. Cézanne is also celebrated for his many portraits (as well as his still lifes), and, most of all, for those works in which he effectively neutralized the internal sense of order and clarity that illusionism is supposed to convey. The Picabia picture, by contrast, taunts us with its utter lack of psychological depth (monkey see, monkey do). In turn, it subscribes to neither traditional illusionism nor Cézanne's dismantling of it, but rather rejects pictorial space altogether in favor of real space—a real toy mounted on a real backboard—and, in the process, hammers a last nail into the coffin of illusionism. Renoir, for his part, produced many of French Impressionism's finest portraits and, throughout his career, demonstrated an unrivaled commitment to the beauty of the human form. Picabia, by substituting a Renoir reclining nude with the grotesque form of a lewdly gesturing monkey, provides us with a reminder not only of Renoir's randy paintbrush but also of how each of us got here in the first place, and, further back, of the family tree from which all of us—man and monkey—descend.

23

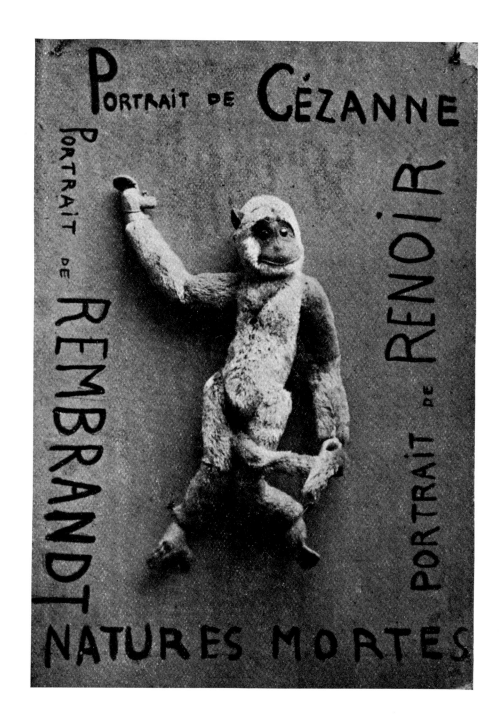

Plate 7
FRANCIS PICABIA. French, 1879–1953
STILL LIFES: PORTRAIT OF REMBRANDT, PORTRAIT OF CÉZANNE, PORTRAIT OF RENOIR. 1920
Toy monkey and oil on paperboard, dimensions unknown. Whereabouts unknown

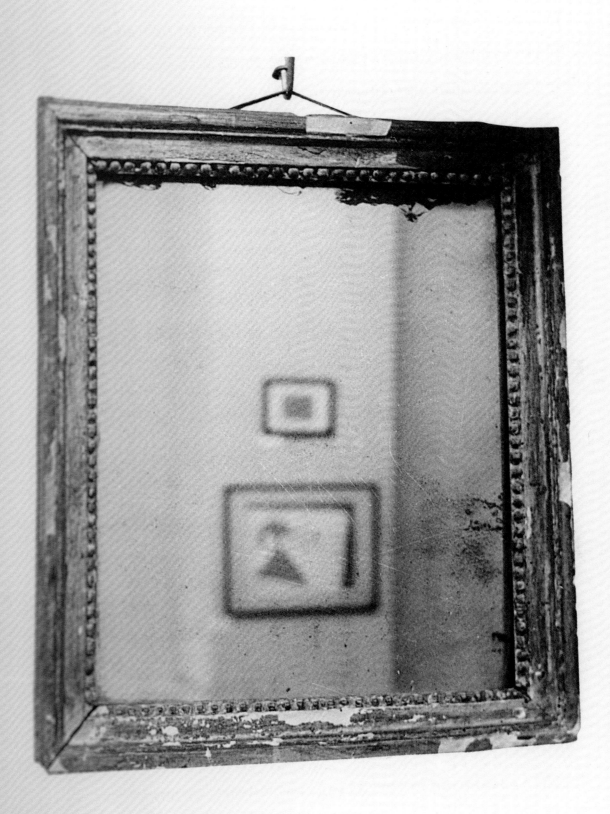

Plate 8
PHILIPPE SOUPAULT. French, 1897–1990
Framed mirror titled **PORTRAIT OF AN UNKNOWN**,
exhibited at the Salon Dada, Paris, June 1921. Dimensions unknown
Whereabouts unknown

While monkeys are famously adept mimics, mirrors are the most faithful mimics of all, a fact with which artists have long played— at least since the Spanish painters Diego Velázquez, in 1656, and later Francisco Goya, in 1800, painted their renowned portraits of the families of Philip IV and Carlos IV as if reflected in a mirror. By brazenly exhibiting a framed mirror titled *Portrait of an Unknown* (plate 8) at the Paris *Salon Dada* exhibition in 1921, Philippe Soupault sealed this historical deal between portraits and mirrors. Indeed, if a mounted monkey makes a traditional still life seem quaint by comparison, a framed mirror pushes the traditional idea of portraiture as mirror about as far as it can go. And if Picabia's monkey mimics (even as it mocks) your good looks, Soupault's title takes your good name, too, and effectively erases it.

Neither the Picabia nor the Soupault work exists today—each is only known through reproductions, which speaks volumes as to their ultimately conceptual significance. For all their Dada shenanigans, Picabia and Soupault are questioning the increasingly elusive difference between the traditionally distinct domains of life and (its transformation into) art. Although the toy monkey and the inscription are, respectively, the very stuff of Picabia's picture and frame, a toy monkey is no more an artistic depiction than a string of words is a physical enclosure. More dramatically yet, what lies within Soupault's frame is contingent on what lies without it. What is reflected in the mirror's surface is entirely changeable and dependent on the real world beyond its frame, as in Duchamp's earlier *To Be Looked At (From the Other Side of the Glass) with One Eye, Close To, for Almost an Hour* (see pp. 9–14).

Most interesting of all is how Picabia and Soupault shun creating those elements in their works that might be said to be based on that pivotal point of traditional picture making—resemblance. Picabia did not paint a monkey, nor did he fabricate the one we see here (which, like Picasso's chair caning, in reality is also fake). And Soupault created neither the mirror nor the image it reflects. The artistic value Picabia and Soupault add to these objects consists of their challenging new contexts (from everyday objects to artistic ones), wittily played out by the provocative titles. Perhaps in their investigation of the difference between life and art, Picabia and Soupault are suggesting that traditional boundaries are not all they're cracked up to be—in fact, that by 1920 they had simply cracked.

R I S K Y
busiNESS

For many Dada artists, especially those who immigrated to neutral cities like Zurich and New York in the early years of World War I, their artistic mantra of leaving things to chance was not only a form of personal protest but also a monkey wrench with which they hoped to disrupt the increasingly mechanized, and frequently violent, world in which they lived. Prior to the outbreak of war, any number of artists—most notably, the Italian Futurists—had already been celebrating the advent of new technologies. But even after the eruption of hostilities, many who survived kept right on celebrating what Futurist Gino Severini, for one, called "Plastic Art of the War," glorifying in such paintings as his 1915 *Armored Train in Action* (above).

While the Futurists found poetry in war machines, Tristan Tzara, an eccentric, Johnny Appleseed–like poet and polemist best known for sowing the seeds of Dada from place to place, railed against the increasingly bellicose logic of his times, and its progressive reduction of humanity to calculating (and even

killing) machines. A veritable gremlin in the poetic works, Tzara formulated the following recipe for making a Dada poem in his 1920 "Dada Manifesto on Feeble Love and Bitter Love." The poem can be concocted from any ingredients so long as they are combined by chance: "Take a newspaper./ Take some scissors./ Choose from this paper an article of the length you want to make your poem./ Cut out the article. Next carefully cut out each of the words that makes up this article and put/ them all in a bag. Shake gently./ Next take out each cutting one after the other./ Copy conscientiously in the order in which they left the bag./ The poem will resemble you./ And there you are—an infinitely original author of charming sensibility, even though unappreciated by the vulgar herd."

In some sense, Tzara was only scrambling the egg that his fellow Dada émigré to Zurich, Arp, had already hatched in a group of collages dating from 1916 to 1917 and (purportedly) "arranged according to the laws of chance" (plate 9). Arp later recalled that he

27

GINO SEVERINI. Italian, 1883–1966
ARMORED TRAIN IN ACTION. 1915
Oil on canvas, 45⅝ x 34⅞" (115.8 x 88.5 cm)
The Museum of Modern Art, New York.
Gift of Richard S. Zeisler

had been working on a drawing when, dissatisfied with the results, he tore it up and let its pieces scatter to the ground. Struck by the pattern into which they had arranged themselves, Arp resolved to glue them down as they lay, and thus were born his collages that might more accurately be described as "assisted" according to the laws of chance rather than "arranged" by them. For what makes Arp's collage exceptional is its sense not that total chaos prevails nor that an overarching order has been imposed, but rather how deftly he negotiates the space between a chance event and an intentional one.

The five white and ten blue uneven squares that make up Arp's *Collage with Squares Arranged According to the Laws of Chance* are in no sense arranged willy-nilly. No two overlap or even touch—of course the chance of this happening, as proved by children's games ranging from (the first throw of) jacks or marbles to pickup sticks, is just about nil. A sort of invisible centripetal force seems to be acting on the squares, inexorably drawing them toward the composition's center, where, except for the diminutive blue square mischievously playing at bottom, they subtly rearrange themselves into two rectangles. The smaller of these two groups contains six hand-torn shapes lying three across in each of the composition's two upper rows, perched on a larger group containing eight hand-torn shapes lying four across in each of the composition's two bottom rows. (On the comparable rectangle-within-rectangle construction of Schwitters's *Merz Picture 32A [The Cherry Picture]*, see pp. 15–21.)

Just as an accountant's spreadsheet wrests order from the chaos of shoeboxes

filled with financial records, the grid it constitutes is not only the preeminent means of organizing unruly scraps of paper but also the very figure of reason and rationality. With the grid comes the underlying syntax—indeed, the unifying language—necessary for random bits of information to cohere and communicate effectively. In Arp's *Collage*, too, we find something of an overall sense of order in the composition's four rows, correspondingly divided into, and balanced by, its four columns. Distinct from the fuguelike music of the classical grid, however, which remains the same whether flipped upside-down, turned backward, or inverted as in a mirror, the composition of *Collage* is akin to the improvised, irregular cadences typical of jazz music; here too, a percussive beat alternates between larger and smaller, blue and white notes of color, all the while punctuated by longer and shorter pauses. Even the fifteen squares that make up *Collage* are, themselves, hand-torn variations on the regularly rectangular, machine-cut theme of their supporting sheet.

Inspired by a vaudeville act, Man Ray's *The Rope Dancer Accompanies Herself with Her Shadows* (1916, plate 10) also flirts with the difference between chance and intentionality, all the while posing fundamental questions about the depiction of movement through time and space. According to its title, the painting's protagonist is the unexpectedly diminutive, almost sticklike figure at the upper edge, just to the right of center. A sort of whirling dervish in the ether, the rope dancer's principal positions are diagrammed and tracked by the corresponding movements of her diaphanous heart-shaped bustier and semi-oval skirt. (On a comparable depiction of movement in

Duchamp's 1912 *Nude Descending a Staircase. No. 2*, see pp. 38–41.) Otherwise, the vast majority of this ambitiously large painting, measuring over four feet high by six feet wide, is reserved for the rope dancer's "shadows," which the artist rendered as a series of flat, overlapping planes.

Like Arp's *Collage*, *The Rope Dancer* also comes with a creation story about an artist's frustration and his ultimate debt to chance. According to Man Ray, his original idea involved drawing the rope dancer in various positions on several sheets of spectrum-colored paper, cutting them out and arranging them in sequence (as a means of suggesting her movement through changes to both her silhouette and the silhouette's color) before beginning the painting. Yet Man Ray was soon displeased with the decorativeness of his composition. He preferred the scraps of papers he had cut away and discarded (in effect, the "negative" forms of the dancer's silhouettes or, as Man Ray described them, "the spaces [...] left outside the original drawings of the dancer") and, especially, the abstract pattern into which they had arranged themselves on

the floor. So he used these negative forms, instead, as templates for painting the dancer's shadows. A circuitous path, to be sure, but ingenious, for it links not only the contours of the rope dancer to both her painted "shadows" and, in turn, to real shadows, but also their progress across the painting's surface to that of the color spectrum.

A real shadow, of course, requires a light source set at an angle to an object and, in turn, an object set at an angle to its shadow: either a three-dimensional world or, as in traditional picture making, a convincing illusion of it. Yet, as with a real shadow, each negative form of the rope dancer's silhouette also tracks the changing contours of her movement through time and space. And whether we are speaking about real shadows (cast on the ground by light) or the rope dancer's shadows (cut from paper and cast on the ground by Man Ray), it is still flat on the ground that we find them. Indeed, just as the rope dancer's shadows began as scraps of spectrum-colored paper lying flat on the studio floor, they ended up as variegated planes of color painted flat on the picture's surface. As such,

Plate 9
JEAN (HANS) ARP. French, born Germany (Alsace). 1886–1966
COLLAGE WITH SQUARES ARRANGED ACCORDING TO THE LAWS OF CHANCE. 1916–17
Torn-and-pasted paper on blue-gray paper, 19⅛ x 13⅝" (48.5 x 34.6 cm)
The Museum of Modern Art, New York. Purchase

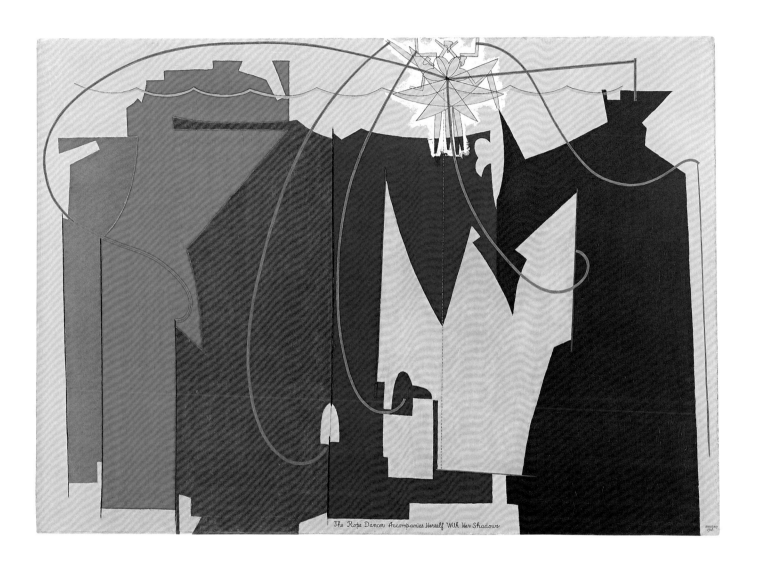

The Rope Dancer Accompanies Herself With Her Shadows

Plate 10
MAN RAY (EMMANUEL RADNITZKY). American, 1890–1976
THE ROPE DANCER ACCOMPANIES HERSELF WITH HER SHADOWS. 1916
Oil on canvas, 52" x 6' 1⅜" (132.1 x 186.4 cm)
The Museum of Modern Art, New York. Gift of G. David Thompson

they ingeniously translate a three-dimensional phenomenon onto a two-dimensional surface—yet without resorting to traditional techniques of perspective, modeling in light and dark, et cetera.

But these flat, anti-illusionistic "shadows" are also remarkable for their kaleidoscopic variety. The spectrum-colored planes (both of the final painting itself and of the cut-out papers on which it is based) are comparable to the colors that make up visible light. However, instead of arranging the rope dancer's shadows in conventional order according to the wavelength of light—red, orange, yellow, green, blue, violet—Man Ray grouped them according to their relationships as primary colors (red, yellow, blue) and complementary colors (for example, red + yellow = orange, the complementary color of blue). We proceed from the complementary colors orange and green (at far left), first to their corresponding primary colors, blue and red

(which Man Ray has inverted at center), then to their common color, yellow (just to the right of center), and, finally, to yellow's complementary color, purple (at far right). Shadows tinged by complementary colors rather than running the traditional gamut from gray to black are among the great innovations of the French Impressionists (and, before them, of Eugène Delacroix), with their green-speckled shadows against ruddy flesh, and great stains of purple shadow cast by yellow sunlight over snowy white fields and dresses. Here, too, we might wonder whether the rope dancer's primary colored shadows are not themselves casting her complementary colored ones. However gifted his dancer with a rope, Man Ray certainly knew a thing or two about tightrope walking, creating painting out of collage, intentionality from chance, movement in both form and color, and, best of all, shadows that cast shadows.

5.

word play

To abandon oneself to the laws of chance was to renounce the talents which had long defined artistic practice—craft, control, intentionality, along with the rules or conventions commonly used to construct pictorial meaning—composition, perspective, modeling. Chance can be applied to both visual and verbal languages. After all, if colors and shapes don't have to work together to create a coherent, plausible view onto another world, why shouldn't letters and punctuation simply be set free from the rules of conventional spelling and grammar? Why couldn't the laws of chance also encourage wordplay, turning letters and words into abstract elements, as with Raoul Hausmann's phonetic poster poem of 1918 (plate 11) and Théo van Doesburg and Schwitters's 1922 poster program for a Dada evening (plate 12)?

The individual letters on Hausmann's poster poem stand about six inches high, inviting them to be read from a distance rather than approached intimately as in a book. The size of the black letters suggests a connection to the world of popular culture, such as the billboard advertisement: scaled for clarity, intended for broad consumption. However, this assembly of letters fails to follow any conventional logic. Instead, letters, pictograms, and punctuation marks remain resolutely on the page as raw utterances, refusing to cohere into familiar words or phrases. Once-familiar letters take on an abstract quality, like the script of a foreign language that one does not understand but admires for its visual pattern and aesthetic continuity. By breaking apart and isolating language's components, Hausmann aimed to recapture the immediacy of pictograms or hieroglyphs, where in a direct "agreement between picture and text," a word such as "eagle" is communicated by a sign that resembles the bird rather than by a sequence of abstract shapes (letters) strung together.

To compose his poster poem, Hausmann instructed a professional typesetter to select letters of moveable type "as they came out of their box—just according to [the

33

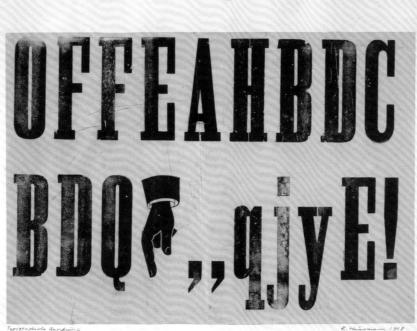

Plate 11
RAOUL HAUSMANN. Austrian, 1886–1971
OFFEAHBDC. 1918
Poster poem, line block, 12 ¹⁵/₁₆ x 18 ¹³/₁₆" (32.5 x 47.8 cm)
Centre Pompidou, Musée national d'art moderne-Centre de création industrielle, Paris. Purchase

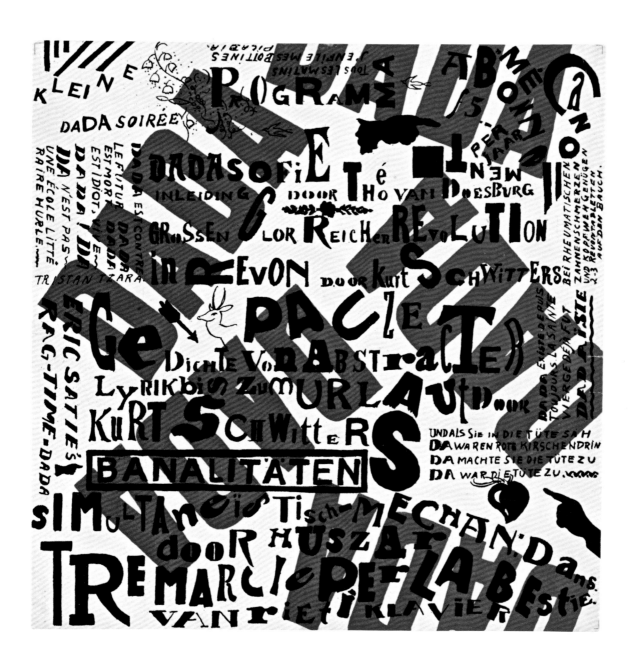

Plate 12
THÉO VAN DOESBURG (C. E. M. KÜPPER). Dutch, 1883–1931;
KURT SCHWITTERS. German, 1887–1948
SMALL DADA EVENING (KLEINE DADA SOIRÉE). 1922
Lithograph, sheet: 11⅞ x 11⅞" (30.2 x 30.2 cm)
The Museum of Modern Art, New York. Gift of Philip Johnson

typesetter's] own mood and chance…. A great *écriture automatique*, automatic writing with question marks, exclamation points, and even a pointer!" In the years to come, automatic writing would become a key strategy of the French Surrealists, who believed that writing without premeditation could access untapped psychic forces. Hausmann, however, was interested in what he called the "raw construction of chance," which involved a fundamental redefinition of the role of the artist. Except for titling, signing, and dating the poster poem, Hausmann's "hand," per se, is absent from the work: the form of the letters is readymade (or machine-made), and their selection and sequencing is determined by the typesetter. Rather than manually executing his work, Hausmann directed its creation as if by remote control, a fundamentally collaborative process that left key decisions open to interventions by chance. The result was a work that severed all logical relationships between letters and their meaning.

The randomly selected typography was ultimately, for Hausmann, just a visual means to provoke an auditory end. When read aloud at a Dada soirée, the poster became a sound poem. According to Hausmann "a chaos of sounds and tones" issued from his mouth as he tried to sound out individual letters that did not conform to the conventional pattern of syllables. Because he believed letters should carry meaning independent of their placement in a word, the sound of each letter was followed by a pause. Uppercase letters were given more emphasis than lowercase ones. The seemingly senseless arrangement of letters provokes us to give it a try, to read the letters out loud and try to make

sense of something that is, in a profound way, nonsense. This exercise in frustration turns the reader from passive recipient of information into active collaborator, performing what Hausmann described as "the multitude of possibilities which our voices offer us… which we produce with the aid of the numerous techniques of breathing, the positioning of the tongue in the palate, the opening of the larynx and the exertion of different degrees of pressure on the vocal cords."

The poster program created by Schwitters and van Doesburg for a series of soirées that comprised their 1923 "Dada Campaign" in Holland presents a discordant pattern rather than an effective information-delivery system. The incongruous appearance of the poster, with words that interrupt each other and shift direction, voice, and language, reflects the tenor of the Dada soirées. Such evenings would commence with pseudo-serious lectures on art interrupted by, say, a barking audience member such as Schwitters, who, having diverted attention away from the program, would then offer his own phonetic poems. In thick red block letters, "DADA" is repeated five times in various orientations as if randomly dropped onto the paper. Black letters, symbols, and a few small images— a deer's head, an arrow, topographic pointers (as found in Hausmann's poster poem)—of varying weight, prominence, and orientation seem to have been cut out from various sources and glued onto the surface. The poster's central zone lists—in German, Dutch, French, and English—the evening's entertainment, which was to include a prelude of "Dadawisdom by Théo van Doesburg," as well as "abstract poems declaimed as loudly

as possible" by Schwitters. Around the periphery, in smaller and more consistent lettering, are notes and comments in French that read like an inside joke while also adding to the "What is Dada" list: "Every morning I slip on my Wellingtons—Picabia"; "Dada is against the future, Dada is dead, Dada is idiotic, Long live Dada!, Dada is not a howling literary school—Tristan Tzara"; and "Dada has always existed. The holy virgin was already a Dadaist."

"THE WORD IS DEAD" and "THE WORD IS POWERLESS," proclaimed van Doesburg, as if in response to the famous opening of "The Gospel According to St. John": "In the beginning was the Word and the Word was God."

To destroy words and disrupt syntax might suggest the ultimate nihilist act. Seizing upon such practices, the Cubist painter Gleizes remarked, "[N]ever has a group disposed of such equipment for saying nothing, and never has a group gone to such lengths to reach the public and bring it nothing." Yet not-so-sweet "nothings" were articulated by disrupting systems of image making and of language construction, making apparent their arbitrary natures and thereby offering new paths of expression and awareness. Such nihilist practices had, paradoxically, a utopian endgame. As van Doesburg concluded, Dada "wants nothing…but nothing in a positive sense."

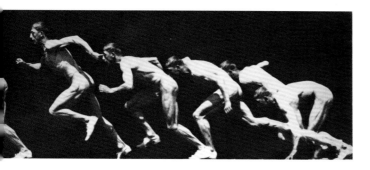

6.

SCANDALOUS MOVEments

The first decade of the twentieth century ushered in entirely new ways of thinking about our ability to move through time and space. Only a few short years separated the Wright brothers' first sustained airplane flight in 1903 and Ford's introduction of the Model T in 1908, events bookending the publication of Albert Einstein's special theory of relativity in 1905, which fundamentally changed our understanding of the relationship between space and time. Artists were quick to keep pace—with Picasso nicknaming his Cubist "brother," Braque, "Wilbourg" (after Wilbur Wright), and the Italian Futurists celebrating the speed of the automobile. In his 1909 "Manifesto of Futurism," Filippo Tommaso Marinetti described his vision of a fire-breathing, cannon-powered automobile: "[T]he world's magnificence has been enriched by a new beauty: the beauty of speed. A racing car whose hood is adorned with great pipes, like serpents of explosive breath—a roaring car that seems to ride on grapeshot is more beautiful than the *Victory of Samothrace*." Even

science fiction was looking a lot like fact, as when Georges Méliès premiered his own flight of fancy, *A Trip to the Moon*, in 1902, building on Thomas Edison's and the Lumière brothers' experimentation with motion pictures.

Although Duchamp acknowledged the general debt that his *Nude Descending a Staircase. No. 2* (1912, plate 13) owed to the nascent motion-picture industry for its sense of movement, the static medium of oil painting (as opposed to motion pictures) of course presented its own special problems. In resolving these, Duchamp was especially indebted to the photographic experiments of Étienne-Jules Marey in the 1880s and, before him, Eadweard Muybridge, in the 1870s. Among his early efforts at stop-action photography, Muybridge employed a series of cameras with their shutters controlled by tripwires and triggered by a running horse to produce serial photographs that captured the horse's sequential movements. In turn, Marey's invention of "chronophotography" enabled photographers to capture successive movements—

38

ÉTIENNE-JULES MAREY. French, 1830–1904
UNTITLED. 1890–1900
Gelatin silver print, 6 1/16 x 14 5/8" (15.4 x 37.2 cm)
The Museum of Modern Art, New York. Gift of Paul F. Walter

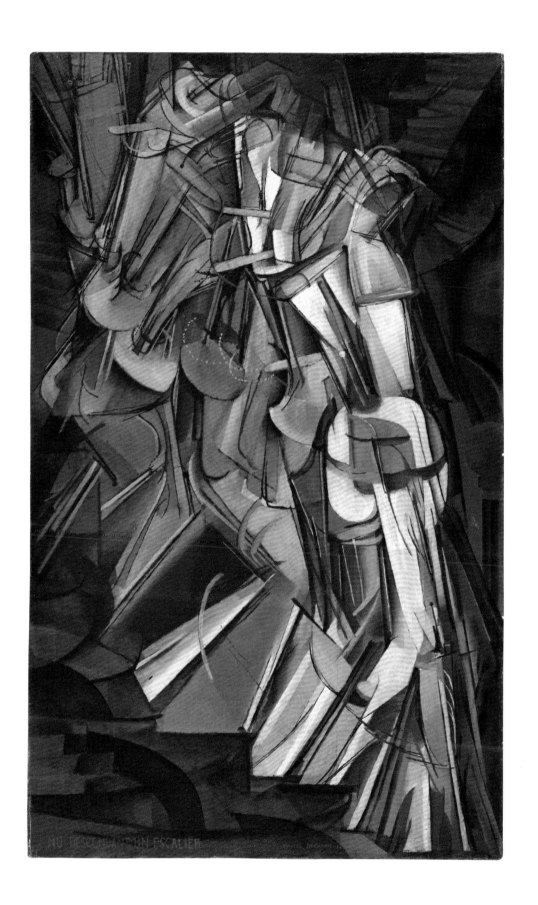

Plate 13
MARCEL DUCHAMP. American, born France. 1887–1968
NUDE DESCENDING A STAIRCASE, NO. 2. 1912
Oil on canvas, 57 ⅞ x 35 ⅛" (147 x 89.2 cm)
Philadelphia Museum of Art.
The Louise and Walter Arensberg Collection

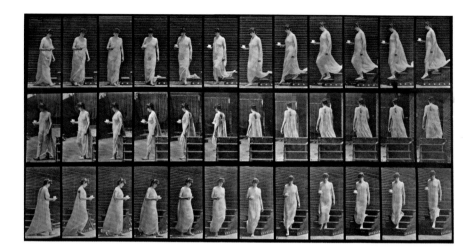

such as those of a bird in flight—on a single photographic plate. As a result, Marey and Muybridge are perhaps best known for producing a stunning array of motion studies focusing on both animals and people—in the latter case including male sprinters (p. 38) and women descending ramps and stairs (above).

Duchamp, too, aimed to capture each step of the *Nude*'s descent as if in the repeated blink of an eye or snap of a shutter. Overall, the *Nude*'s sense of movement is comparable to that of the shifting, overlapping silhouettes of Marey's (or possibly his assistant Georges Demenÿ's) sprinter—or to a flip book of sorts (as we might easily imagine being made from Muybridge's descending woman), but with all the images layered one on top of the other on the same page. Following the *Nude*'s appearance at the 1913 Armory Show, in New York, it was dubbed "The Rude Descending a Staircase (Rush Hour at the Subway)" by J. F. Griswold of the *New York Evening Sun* (p. 41), referring to the inchoate, downward-thrusting appearance

of its silhouettes, which frantically bump and grind into each other like a rush-hour crowd descending into the bowels of the New York City subway.

To achieve his depiction of the body in motion, Duchamp distilled the flickering contours created by the figure's descent into their most linear, bare-boned elements. In the upper third of the painting we see the loose and boxy, almost bobble toy–like movements of the head and rectangular torso, which finally coalesce near the right edge. In the middle third (moving from the left edge toward center), we see the twisting and turning of the pelvis, which, as it descends the stairs, subtly morphs from circular into semicircular arcs, at times with an emphatic dot at center where a vertical line pierces it. In the lower third, right angles alternating with triangular—at times even bell-bottom-shaped forms, make up the sweep of the figure's thighs and calves. Finally, Duchamp wanted us to recognize that not only the *Nude* itself but also its naughty bits— male? female? who can really tell—are also

EADWEARD MUYBRIDGE. British, 1830–1904
WOMAN DESCENDING A STAIRWAY AND TURNING AROUND,
from the book **ANIMAL LOCOMOTION.** c. 1887
Collotype on paper, 7⁷⁄₈ x 15¹⁄₁₆" (20 x 38.6 cm)
Smithsonian American Art Museum, Washington, D.C.

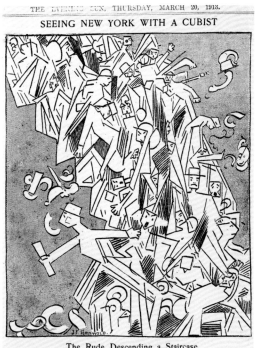

THE EVENING SUN, THURSDAY, MARCH 20, 1913.

SEEING NEW YORK WITH A CUBIST

The Rude Descending a Staircase
(Rush Hour at the Subway)

freely flapping in the breeze. Thus he echoed the twisting and turning of the prominent pelvis as a series of three upturned but interlocked parabolas—unlike the rest of the nude, diagrammed in Morse code–like broken dashes—as if that part of the body were moving independently from the rest.

Duchamp's contemporaries by no means welcomed this unorthodox combination of motion photography and Cubist painting. His use of a restricted palette of earthy colors owes much to classic Cubism, as does the painting's tendency toward abstraction—especially the way that its geometric building-blocks produce the overall effect of an open form made of crisscrossing scaffolding, rather than of a closed, integral one. The tension Duchamp created between the illusion of depth and the fact of flatness—the poles between which every painting necessarily oscillates—also owes much to the ambiguous relationships of figure to ground (foreground to background, et cetera) that Cubism cultivated: in *Nude*, for example, the darker intervals of staircase at each of the

painting's four corners tend to recede, as compared to the silhouettes, which remain flat and parallel to the painting's surface. Perhaps most unwelcome of all, however, was Duchamp's heretical treatment of the revered genre of the French nude. Whether standing or reclining, coquettishly looking away or assertively staring us down, the French nude traditionally basked in her surroundings and luxuriated in her charms, preening and being pampered among the few activities of which she could ever be accused. No French nude, finding herself precariously perched on the precipice of a staircase, had ever been given a shove and sent sallying forth.

Looking back over his career shortly before his death in 1968, Duchamp explained that, "the idea of movement . . . just transferred from the *Nude* into a bicycle wheel." By linking these apparently incomparable objects—an oil painting of a nude and a sculpture that is a bicycle wheel perched on a wood stool—Duchamp emphasizes how both take aim at the problem of incorporating "the idea

SCANDALOUS MOVEMENTS

41

THE RUDE DESCENDING A STAIRCASE (RUSH HOUR AT THE SUBWAY),
NEW YORK EVENING SUN, March 20, 1913
The Museum of Modern Art Archives:
Armory Show Scrapbook, compiled by Harriet S. Palmer

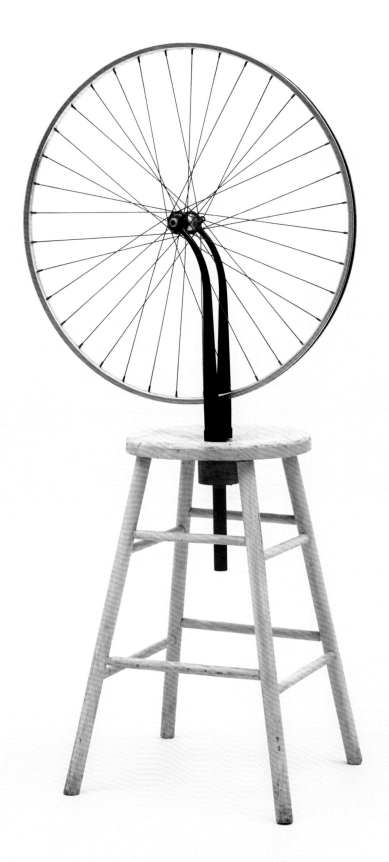

Plate 14
MARCEL DUCHAMP. American, born France. 1887–1968
BICYCLE WHEEL. 1951 (third version, after lost original of 1913)
Metal wheel mounted on painted wood stool,
50 $\frac{1}{2}$ x 25 $\frac{1}{2}$ x 16 $\frac{5}{8}$" (128.3 x 63.8 x 42 cm)
The Museum of Modern Art, New York.
The Sidney and Harriet Janis Collection

of movement" in the visual arts. In fact, the 1913 *Bicycle Wheel* (plate 14, shown here in its third version, from 1951) was the great leap forward that effectively kick-started a tradition of kinetic (including motorized) sculpture. Yet, unlike *Nude*, which for all of its new-fangled ideas expresses them through the old-fashioned medium of oil painting, *Bicycle Wheel*'s repudiation of traditional sculptural materials (for example, marble or bronze) is complete. Most artists and connoisseurs have long been trained to think of artworks as essentially different from, and fundamentally better than, everyday objects. Yet at least since the Cubists first glued newspaper fragments and decorator's materials into their collages, artists were no longer able to rely on the expedient notion that quotidian items like bicycle wheels and wood stools are simply not the stuff of art. That Rubicon, with artists' materials on one side and everything else on the other, had been irrevocably crossed. Twinning the sculpture's makeup from everyday objects with its potential for actual movement, Duchamp sought to overturn one of the great axioms of both art making and art display: that works are made to be looked at, not touched. And in the wake of Cubist collage, he provoked the next logical step—from artworks made of everyday materials that we only look at to ones that we can also touch (bicycle wheels and wood stools, after all, being precisely the sorts of objects we routinely handle).

Nevertheless, there is a line that Duchamp's *Bicycle Wheel* dared not cross.

In a discussion of art and artists that prefaces the 1891 novel *The Picture of Dorian Gray*, Oscar Wilde proposes, "We can forgive a man for making a useful thing as long as he does not admire it. The only excuse for making a useless thing is that one admires it intensely. All art is quite useless." Despite these shifting lines in the sand (and, in the case of Duchamp, some might even say quicksand) between artists' materials and all the rest, between artworks that do or do not move, works that we only look at or that we also touch, *Bicycle Wheel* can be taken for a spin but never for a ride. Hobbled and perched on a wood stool, it is useless for locomotion—even willfully so. In this way, *Bicycle Wheel* preserves the age-old distinction between the lack of everyday usefulness we ascribe to art and the usefulness we demand of everyday objects. In some sense, *Bicycle Wheel* might even be considered old-fashioned. Once upon a time, artworks were embedded in ritualistic processes, and were believed to have metaphysical powers (a cave painting of an animal ensuring a fruitful hunt, a religious icon promising good health and fortune). By contrast, Duchamp endowed *Bicycle Wheel* with everyday powers to bring about a metaphysical event—an inquiry into the limits of what can properly constitute art in general and sculpture in particular. And the artwork, in turn, has been restored to its age-old ritualistic origins, albeit now as a purely cyclical—some might say cynical—exercise.

7.

SCANDALOUS EXHIBITIONS

Writing on the eve of World War II, the German essayist and critic Walter Benjamin remarked how the rise of photography and film had irrevocably changed not only how modern audiences perceived these newer art forms, but also how they understood and appreciated artworks more generally. For Benjamin, it was not merely a question of most people never having actually seen (in the flesh, so to speak) any number of artworks with which we are nevertheless familiar in reproduction—Leonardo da Vinci's *Mona Lisa*, say, in the pre–jet age. More to the point, he recognized that artists themselves had begun increasingly to rely on strategies of mechanical reproduction, producing artworks intended to exist solely as copies or which otherwise anticipate the possibility of their reproduction right from the start. Benjamin was among the first critics of material culture to articulate both the historical context of this important trend—in effect, the new standing that artists had begun affording copies—as well as its sweeping consequences. "[F]or the first time in world history,"

he wrote in his classic 1936 essay "The Work of Art in the Age of Mechanical Reproduction," "[t]he work of art reproduced becomes the work of art designed for reproducibility. From a photographic negative, for example, one can make any number of prints; to ask for the 'authentic' print makes no sense."

Some two decades earlier, Duchamp had coined the term "Readymade" to describe certain of his artworks that rely on mechanical reproductive strategies and incorporate mass-manufactured objects. Those Readymades which Duchamp merely repositioned (or in some way recontextualized) and inscribed, but otherwise left essentially as he found or bought them—such as the men's-room urinal that he upended, signed (with a pseudonym), and dated (*Fountain*, 1917, plate 15)—are known as "unassisted." "Assisted" Readymades describe those which he fundamentally altered or modified in some way—like the bicycle wheel he attached to a stool (see plate 14), or the inexpensive chromolithograph (akin to a modern-day postcard) of Leonardo's

44

Mona Lisa, to which he added in 1919 a moustache and goatee. As such, Duchamp's Readymades are a sort of take-no-prisoners interrogation of the difference between a machine-made commodity and a handmade artwork, although they are no less vexing with respect to how an "original" artwork differs from an artwork as "copy." Indeed, in the case of Duchamp's first Readymade and its infamous progeny—the 1913 *Bicycle Wheel* and the 1917 *Fountain*—the "original" versions are irretrievably lost, replaced by a variety of copies that run the gamut from full- to dollhouse-sized replicas of *Fountain* to a series of color prints based on a black-and-white photograph of a 1916 replica of the 1913 *Bicycle Wheel*.

Not only does the Readymade rely on the techniques and strategies of mechanical reproduction, it constitutes a copy that, paradoxically, lacks an original. Unlike limited-edition, even posthumous bronze casts of original sculptures by such modern masters as Hilaire-Germain-Edgar Degas and Auguste Rodin, *Bicycle Wheel* and *Fountain* stand for exactly the opposite proposition: there never was an "original," properly speaking, in the first place. To speak of the original of *Fountain*, for example, is as nonsensical as speaking of the original from among any number of identical men's-room urinals that the J. L. Mott Iron Works Company churned out in the early twentieth century, any one of which Duchamp chose (and admits to by the fact of signing the work "R. Mutt," a bit of wordplay on, among other things, the corporate name of its "true" creator, J. L. Mott). As an unnamed critic (whom some believe to have been Duchamp himself) pointed out at the time, whether "Mr. Mutt

with his own hands made the fountain has no importance. He CHOSE it. He took an ordinary article of life, placed it so that its useful significance disappeared under the new title and point of view."

When Alfred Stieglitz photographed the first version of *Fountain*, he doubtless realized—whether or not he actually appreciated—its irony. Playing up the difference between a machine-made sculpture and a handmade painting (and, perhaps, between a not-necessarily-true artwork and a most-definitely-true one), Stieglitz carefully positioned Duchamp's *Fountain* in front of Hartley's *The Warriors* (1913)—the painting that we see on the rear wall. What is more, Stieglitz photographed the urinal with its "price tag" still attached (actually, the label from the first exhibition of the Society of Independent Artists, to which Duchamp had submitted *Fountain* the same year)—no different from how commodities of every sort come with price tags. Although we might speak of the "original" of *Bicycle Wheel* with greater cause—after all, Duchamp didn't just choose it *as is* but at the very least assisted its two (admittedly prefabricated) parts to come together by hand—not only did he leave the first version of *Bicycle Wheel* behind in Paris when he sailed for New York, the second version, made after his arrival in the United States, is also lost. As a result, the earliest, extant versions of *Bicycle Wheel* and *Fountain* are both from the early 1950s.

Unlike the common origins of *Fountain*, the source of Duchamp's *L.H.O.O.Q.* could not be more venerable. Beginning with a reproduction of the *Mona Lisa*—since 1503, a paragon of everything that the unique

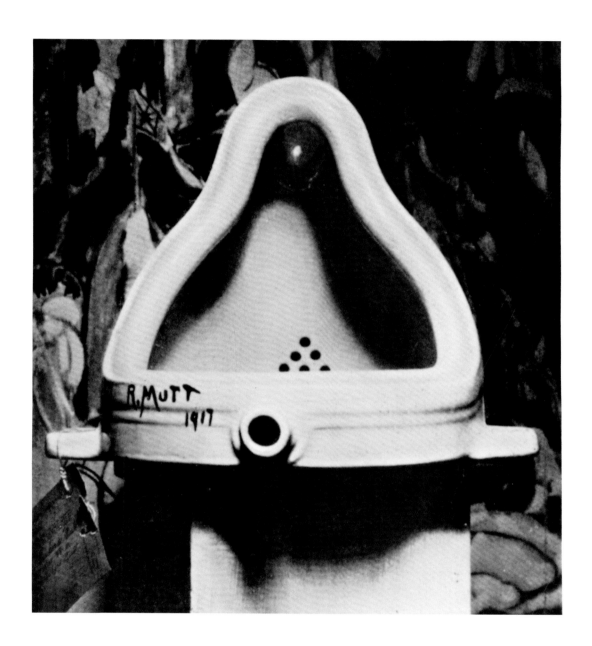

Plate 15
MARCEL DUCHAMP. American, born France. 1887–1968
FOUNTAIN. 1917
Unassisted Readymade: porcelain urinal turned on its back, dimensions variable
Photographed by Alfred Stieglitz
Gelatin silver print, 9¼ x 7" (23.5 x 17.8 cm)
Succession Marcel Duchamp, Villiers-sous-Grez, France

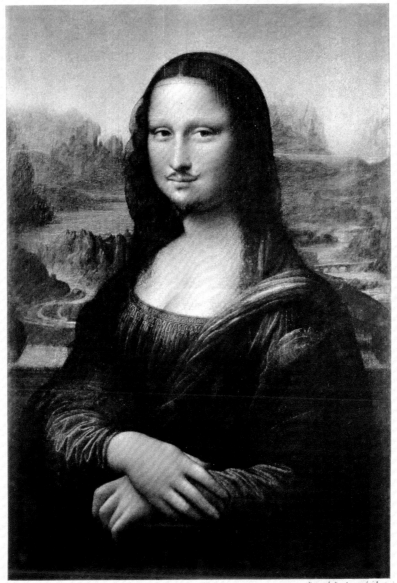

L. H. O. O. Q.

Plate 16
MARCEL DUCHAMP. American, born France. 1887–1968
L.H.O.O.Q. 1930
Assisted Readymade: Pencil on reproduction, 25½ x 19" (64.7 x 48.2 cm)
Collection of the French Communist Party, Louis Aragon, on loan to the
Centre Pompidou, Musée national d'art moderne, Paris

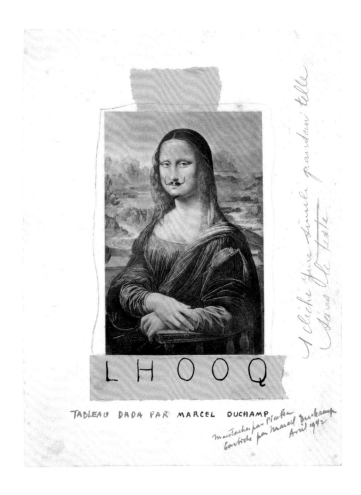

and original handmade artwork embodies—
Duchamp ended by penciling in a moustache
and goatee, together with the letters
"L.H.O.O.Q.," at bottom. With just a few strokes
of his Dada pencil, Duchamp both defamed
one of the best-known and -loved pictures of
all time and, more importantly, created his
own "original" artwork: an original that is
simultaneously a copy of Leonardo's. (And
given the theft of the *Mona Lisa* earlier that
decade, the idea of "replacing" it with a
copy—especially a defaced one—must have
been all the more tantalizing.) Although the
first version of *L.H.O.O.Q.* is still in existence,
so are myriad copies and versions that
Duchamp reissued over the years, including
his 1930 copy of his first copy of Leonardo's
original—shown at a major exhibition in Paris
the same year (plate 16). Indeed, when

L.H.O.O.Q. was reproduced for the first
time—in an issue of Francis Picabia's avant-
garde journal *391*, in 1920—rather than running
the original version (which had been delayed),
Picabia simply made his own version, in which
he included the moustache but forgot the
goatee. Duchamp later added the missing
goatee and signed Picabia's copy "Moustache
by Picabia, beard by Marcel Duchamp"
(above)— thus creating what must be the
greatest elegy ever written to the proliferating
powers of the copy over the original (not to
mention of mass reproduction over artistic
production).

In the aftermath of the Readymades,
perhaps anyone can choose anything, even a
length of blank canvas, hang it on a wall,
and call it art. Yet, as critic Clement Greenberg
once warned, even if "a stretched or tacked-

LOOKING AT DADA

48

MARCEL DUCHAMP. American, born France. 1887–1968
L.H.O.O.Q. 1920/42
Replica by Francis Picabia, 1920 ("completed" by Duchamp in 1942)
Engraving and pasted pieces of paper, handwritten inscriptions in
pencil and ink, 9¼ x 7" (23.8 x 17.8 cm)
Francis M. Naumann Fine Art, New York

up canvas already exists as a picture," it is "not necessarily [. . .] a successful one." What makes these Readymades successful is not only the elegantly economical way they question the difference between artistic objects and objects of everyday life, but also how their subject matter is every bit as topsy-turvy as taking an object from an assembly line and designating it an original artwork in the context of a gallery or museum. By virtue of a simple rotation of axis, from a vertical basin into a horizontal one, a urinal is now—presto chango!—a fountain: once intended to receive a stream of fluid, it would now emit one, and once solely reserved for male functions, it had become a metaphor for female ones, as in "The Song of Songs," where a bride is described as "a spring shut up, a fountain sealed." So too, by the simple expedient of adding a few whiskers to the *Mona Lisa*, the sitter is revealed to be at one and the same time both herself and her alter-ego: "…the *Mona Lisa* becomes a man," Duchamp explained. "It is not a woman disguised as a man; it is a real man, and that was my discovery, without realizing it at the time." The title slyly suggests, nevertheless, that she may in fact be all woman. Pronounced in French in quick succession, the letters of the title (L-H-O-O-Q) become "*elle a chaud au cul*"—in English, loosely, "she has a hot ass."

Although the Readymades' influence on twentieth-century art cannot be overstated, it bears mention how Duchamp once protested that he threw a "urinal into [postwar artists'] faces as a challenge and now they admire [it] for [its] aesthetic beauty." True, *Fountain*'s great round basin did at the time elicit comparison to the Buddha's belly—as in Louise Norton's 1917 article, "Buddha of the Bathroom" and Alfred Stieglitz's assertion that the urinal's "fine lines" suggested a "Buddha form." Indeed, by accentuating the urinal's sweeping, cowl-like silhouette, Stieglitz's photograph even occasioned *Fountain*'s being compared to the mantle of the Virgin Mary as well as being nicknamed the "Madonna of the Bathroom." Of course, all this tongue-in-cheek canonization of an unholy urinal only raised the stakes of Duchamp's artistic iconoclasm to outright heresy. But, more importantly, if *Fountain* is beautiful, its beauty lies in its engineered, but not mechanized, form—one without moving parts, which is simple and whole in itself and even serves as an avatar of sorts—conjuring a basic shape of the human form (not to mention its fundamental functions). As Duchamp once remarked to the Romanian sculptor Constantin Brancusi at a Paris aviation show, "Painting is over and done with. Who could do anything better than this propeller? Look, could you do that?"

8.

funny PHYSICS

The ticking of a wristwatch, revolving throb of a phonograph, flickering light of a silent film, din of an assembly line—lived experience in the early twentieth century was newly articulated by such mechanical idioms. With its power both to improve life and systematically destroy it, the machine was a critical new force. Technology, for all its pretensions to promoting Enlightenment ideals of reason and rationality, began looking more and more unreasonable, and, at times, even irrational to Dada artists— and never more so than when science betrayed its humanist origins in favor of devising ever newer and more effective killing machines with which to fight World War I.

The seemingly benign systems of measure and logic that enabled the machine's celebrated apotheosis were revealed to be harbingers of destruction, fundamentally shaking naïve belief in ideals, facts, and absolutes. Duchamp's *3 Standard Stoppages* (1913–14, plate 17) challenges the rational underlying standards of measure and is as much a record of a pseudoscientific demonstration as it is an artistic composition. His stated premise for the work reads like a theorem: "If a straight horizontal thread one meter long falls from a height of one meter on to a horizontal plane twisting *as it pleases* [it] creates a new image of the unit of length." Which is precisely what Duchamp did: he dropped three threads one meter in length from the height of one meter onto three stretched canvases painted Prussian blue. Having fallen as they pleased, the threads were varnished onto the canvases to preserve their resting place, and the canvases were cut from the stretchers and glued onto plates of glass. Finally, three wood strips were cut according to the curves the threads assumed upon landing, creating templates of their profiles. When asked why he favored three in number, the artist replied: "One is unity, two is double, duality, and three is the rest." The resulting "rulers" were housed in a box looking much "like the cases made for croquet sets" (a perfect example of "canned chance," as the artist remarked). While the demure box may give the pretense of a game

Plate 17 (and opposite)
MARCEL DUCHAMP. American, born France. 1887–1968
3 STANDARD STOPPAGES. 1913–14
Wood box: 11 1/8 x 50 7/8 x 9" (28.2 x 129.2 x 22.7 cm), with three threads: 39 3/8" (100 cm),
glued to three painted canvas strips: 5 1/4 x 47 1/4" (13.3 x 120 cm),
each mounted on a glass panel: 7 1/4 x 49 3/8 x 1/4" (18.4 x 125.4 x 0.6 cm),
three wood slats: 2 1/2 x 43 x 1/8" (6.2 x 109.2 x 0.2 cm), shaped along one edge to match the curves of the threads
The Museum of Modern Art, New York. Katherine S. Dreier Bequest

with rules, like Alice's croquet match in Wonderland it is anything but. Likewise, the title—derived from the French term "*stoppages*," used by tailors to describe "invisible mending" that stops the unraveling of worn cloth—puts thread to work in a capacity that is anything but invisible.

It is "a joke about the meter," Duchamp glibly noted when completing a MoMA questionnaire about the piece. After all, we blindly accept a system of measurement based on the somewhat arbitrary length of a meter (its length originally determined by the premise that the Earth's circumference should measure forty million meters). In fact, a meter is but the distance between two scratches on a metal bar housed in a temperature-controlled room in the Académie des Sciences, in a suburb of Paris. As Duchamp explained in 1964, "This experiment [*3 Standard Stoppages*] was made in 1913 to imprison and preserve forms obtained through chance, through my chance. At the same time, the unit of length [...] one meter [...] was changed from a straight line to a curved line without actually losing its identity [as] the meter, and yet casting a pataphysical doubt on the concept of a straight edge as being the shortest route from one point to another." A philosophy dedicated to imaginary solutions, "pataphysics," coined by the French writer Alfred Jarry, is an absurdist concept intended to parody the methods of modern science.

While this close encounter of chance and science may appear to be governed simply by the desire to provoke, Duchamp's "approximate reconstitution of the unit of length" is not without scientific resonance. It is contemporary with the first challenges to Euclid's notion of the fixed line, which would give rise to non-Euclidean geometry. Similarly, Albert Einstein's theories of relativity, proposed in various forms between 1905 and 1915, not only had specific implications for physics, they also demonstrated that no frame of reference is more valid than another. So too, one could argue, any system of measurement is as valid as another. Duchamp's premise, experiment, and resulting apparatus question truth and absolutes: "the word 'law' is against my principles," the artist once noted. "Every fifty years or so a new 'law' is discovered that changes everything [...] so I had to give another sort of explanation."

While Duchamp tested the limits of the artist's métier, his melding of art and science was not unlike Renaissance artists' experimentation with the laws of optics to give the impression of three-dimensional space in two dimensions. In 1918, Duchamp proclaimed that he had renounced painting, preferring instead to play chess and pursue his interest in optical phenomena in order to "escape the confines of art's retinal appeal and instill an intellectual one." In this capacity, he embarked on a number of pieces that he referred to as "precision optics." *Rotary Demisphere (Precision Optics)* (1925, plate 18) consists of half a papier-mâché globe painted white, with black concentric circles arranged so as to suggest a spiral. A copper collar with protective glass dome frames the demisphere, separating it from the more practical aspects of the sculpture—metal stand, pulley, and motor. Engraved with rather authoritative roman lettering, the copper disc bears a seemingly arbitrary pun, composed for the sound the words

make together: "*Esquivons les ecchymoses des esquimaux aux mots exquises*," which loosely translates as "Let us dodge the eskimos' bruises with exquisite words."

For optimal impact, viewers (or rather test subjects) of *Rotary Demisphere* are instructed to stand one meter away from the machine for a period of time. When operated, the black circles give way to an undulating spiral that seems to protrude into the viewer's space and plunge back into the demisphere, giving the illusion of an additional (ephemeral) dimension. The optical effect of hypnotic circles was to be complemented by the auditory impact of the repetitive French syllables—*esqu, ecchy, esqui, exqui*—of the inscribed words. As much optical experiment as work of art, Duchamp preferred not to exhibit the piece, stating: "I would regret it if anyone saw in this globe anything other than 'optics.'" Indeed, the contraption might seem more at home in a laboratory than an art gallery, where the relationship between object and viewer is not so genteel. To experience the work, we must be willing to subject ourselves to a pseudoscientific experiment, one intended by the artist to afford a means of access to an unknown fourth dimension.

Man Ray also intended his *Indestructible Object (or Object to Be Destroyed)* (plate 19) to incite active audience participation, this time in the form of a do-it-yourself experience. Conceived in 1923, *Indestructible Object* consists of a metronome with attached eye cut out from a photograph. Instructions accompanying Man Ray's 1932 drawing of the object detail the steps necessary for its realization: "Cut out the eye from the photograph of one who has been loved but is seen no more. Attach the eye to the pendulum of a metronome and regulate the weight to suit the tempo desired. Keep going to the limit of endurance. With a hammer well-aimed, try to destroy the whole at a single blow." While the components of this piece do not hold obvious aesthetic value, it is in their selection and assembly that meaning takes form. As Man Ray explained, "This is a poetic conception, like a poem made up of words already to be found in a dictionary! The elements that compose the object do not by themselves have any creative value." In a later version of the work, Man Ray attached a photograph of an eye of Lee Miller, a photographer and studio assistant with whom he had had an affair. Although tame enough at rest, imagine the staccato ticking of the metronome, the taunting eye of a once-beloved relentlessly waving back and forth, counting off the duration of your engagement with the piece, until, driven to desperation, you smash it.

Man Ray proposes an aggressive act transgressing the sanctity of the art object and our habitual reverence for the artist's craft and product. Iconoclasm has been practiced for as long as art has existed, the destruction or defacement of religious images and symbols ostensibly undermining their power. Man Ray's "instructions" encourage such behavior, admitting the possibility of endlessly repeated destructive acts of personal and psychic release. But here there is no "true," "original" work of art. This 1964 work is a replica of the work conceived in 1923. Given the fact that multiple versions of *Indestructible Object* made during Man Ray's lifetime have survived, one might wonder if the artist ultimately prized the object that carries with it the

Plate 18
MARCEL DUCHAMP. American, born France. 1887–1968
ROTARY DEMISPHERE (PRECISION OPTICS). 1925
Motor-driven construction: painted wood demisphere, fitted on black velvet disk,
copper collar with plexiglass dome, motor, pulley, and metal stand,
58½ x 25¼ x 24" (148.6 x 64.2 x 60.9 cm)
The Museum of Modern Art, New York. Gift of Mrs. William Sisler and Edward James Fund

Plate 19
MAN RAY (EMMANUEL RADNITZKY). American, 1890–1976
INDESTRUCTIBLE OBJECT (OR OBJECT TO BE DESTROYED). 1964 (replica of 1923 original)
Metronome with cut-out photograph of eye on pendulum,
8⅞ x 4⅜ x 4⅝" (22.5 x 11 x 11.6 cm)
The Museum of Modern Art, New York. James Thrall Soby Fund

tantalizing potential to be destroyed above the actual act of destruction. Late in life, Man Ray expressed the wish to destroy the work in front of an audience during the "course of a lecture," but this seems never to have transpired. In 1957, students demonstrating against Dada at a Paris gallery carried off a version of the object and presumably destroyed it. When the artist filed with an insurance company, its representative, according to Man Ray "voiced his suspicion that I might, with this money, buy a whole stock of metronomes. 'That was my intention,' I replied; however, I assured him of one thing—I'd change the title—instead of *Object to Be Destroyed* I'd call it *Indestructible Object*." Indeed, Man Ray had orchestrated an indestructible scenario sustained by a theoretically unlimited supply of metronomes and photographs that could be united by an idea innumerable times.

While technology may have threatened to usurp human touch, Duchamp and Man Ray, like inventors themselves, were provoked by technology, questioning its methods and offering alternative ways of seeing that depended not on craftsmanship but rather on thinking. As Man Ray aptly summed it up: "In whatever form [the idea] is finally presented, by a drawing, by a painting, by a photograph, or by the object itself in its original material and dimensions, it is designed to amuse, bewilder, annoy, or to inspire reflection, but not to arouse admiration for any technical excellence usually sought for in works of art. The streets are full of admirable craftsmen, but so few practical dreamers."

9.
eye
in HAND

In the early 1920s, Man Ray began producing a series of cameraless photographs, which he not so modestly dubbed "rayographs." In fact, the technique of cameraless photography dates back to the beginnings of photography, while the images it produces are more generally known as "photograms." To make a photogram, objects are placed directly onto light-sensitive paper and exposed to light, rather than captured at a distance through the lens of a camera. When developed, the print effectively yields a "negative" image of the subject matter such that the areas least exposed to light come out lightest and the areas most exposed to light come out darkest. In Man Ray's *Rayograph* of 1923, for example (plate 20), the oval shape at the far right grows progressively darker from its luminous center (where the object directly touched the light-sensitive paper) to its edges (where it only partially blocked the light and produced a penumbra of gray tones) to its periphery and surrounding black areas (where light was not blocked).

By capturing not the objects themselves but rather the shadowlike imagery they cast, Man Ray diverged from the traditional verisimilitude of photography in favor of its capacity for abstraction. Developing from blocked light rather than reflected light (as in conventional photography), images in photograms, like shadows on the ground, are often so mysterious as to verge on the unrecognizable. The oval shape to the far right of Man Ray's photogram, for example, could be the bulb of a photographic apparatus, such as a suction device, or could just as easily be a lemon or a lime, an egg, or any other ovoid object. The bright white strand above center suggests a bracelet, and the form thrown deep into shadow diagonally to the left suggests a pipe, but the object that sprawls across the bottom edge and then, running diagonally, terminates in a mushroom shape in the upper-left corner, is far more enigmatic. In the ambiguity of their forms, Man Ray's photograms demand that we focus our attention not only on what we can see, but also on

57

Plate 20
MAN RAY (EMMANUEL RADNITZKY). American, 1890–1976
RAYOGRAPH. 1923
Gelatin silver print, 11⁹⁄₁₆ x 9⅛" (29.4 x 23.2 cm)
The Museum of Modern Art, New York. Gift of James Thrall Soby

Plate 21
MAX ERNST. French, born Germany. 1891–1976
THE CHINESE NIGHTINGALE. 1920
Ink on paper mounted on board, 4^{13}/$_{16}$ x 3^{1}/$_{2}$" (12.2 x 8.8 cm)
Musée de Grenoble

what we cannot: the concrete—but often unknowable—objects that lurk "behind" the shadowlike forms; revealing, in the process, how one object can take many forms and how one form can embody many objects.

As a painter critical of painting, Man Ray aimed to free himself from "the sticky medium of paint," which makes it all the more ironic that he conceptualized his photograms in relation to paintings and painterly techniques. As Man Ray explained, "I was trying to do with photography what painters were doing, but with light and chemicals, instead of pigment, and without the optical help of the camera." Indeed, in the nearly century-long sibling rivalry between photography and painting, the newer art form (photography), in exploring its limitless potential to realize abstract effects, is also asserting its comparable status to the older art form (painting). It is at moments like this that photography and painting come together, with the traditional transparency and verisimilitude embodied by both the lens of photography as well as the "window" of painting simultaneously rejected in favor of their opposite terms: opacity and abstraction.

We tend to think of the camera lens as an extension of the photographer's eye and a metaphor for sight, just as we think of the paintbrush as an extension of the painter's hand and a metaphor for touch. As with photomontage, in which objects appear arrayed against an often neutral support, or commercial photography, in which an art director similarly sets up the shot, a photographer working on a photogram, rather than visually framing a preexisting view, must physically arrange the objects in the first place. What is more, unlike the foreseeable relationship between what we see through the viewfinder and the view found in the ensuing photographic print, the shadowlike imagery that the objects cast in a photogram is not so predictable. Bringing together the photographer's hand and the object's "touch" as the primary vehicles for composing their imagery, Man Ray's "rayographs" are ironic, named as they are for an artist who disliked this hands-on aspect of art making most of all, and even turned to airbrushing (a compressed-air device used for spray painting) as a means of maximizing the distance between his hand and his art.

"I began as a painter," Man Ray has explained. "In photographing my canvasses I discovered the value of reproduction in black and white. The day came when I destroyed the painting and kept the reproduction. From then on I never stopped believing that painting is an obsolete form of expression and that photography will dethrone it when the public is visually educated." So, too, Max Ernst's *The Chinese Nightingale* (plate 21), from 1920, is a collage that he photographed later that year. Unlike Man Ray, however, Ernst did not destroy the original work but rather considered the photographic print to be an

English aviation bomb from Georg Paul Neumann's *Deutsches Kriegsflugwesen* (German military aviation). Bielefeld and Leipzig, 1917, p. 32. Rotated

Plate 22
EL LISSITZKY. Russian, 1890–1941
KURT SCHWITTERS. 1924
Gelatin silver printing-out-paper print, 4³/₁₆ x 3¹¹/₁₆" (10.6 x 9.4 cm)
The Museum of Modern Art, New York. Thomas Walther Collection. Purchase

artwork separate and distinct from the one it reproduces. Either way, photography—inherently multiple by nature—acquires the full artistic force and effect of a unique and original painting or collage (and, in the case of Man Ray, even supplants it).

What is more, *The Chinese Nightingale* not only ended up as a photograph but also started out as one. The source of Ernst's imagery is a photograph of an English bomb, reproduced in Georg Paul Neumann's 1917 book *Deutsches Kriegsflugwesen* (German military aviation) (p. 60). Rotating the photograph of the bomb ninety degrees, Ernst decked it out with a fan-shaped tiara and added cut-out photographs of an eye and two arms, lending it the overall appearance of a girl reclining on grass. Ernst photographed this first version of *The Chinese Nightingale*, a collage, to make the second version—a photograph of a collage that itself consists of photographs. The second version of *The Chinese Nightingale* is not merely a photograph that records an artwork—it is an artwork that records photography's unique ability to seamlessly unite disparate parts into a smooth, hallucinatory whole.

El Lissitzky's 1924 portrait of Schwitters (plate 22) is also a photograph of a collage that consists of photographic materials. Here, two photographic negatives, from a pair of portraits that El Lissitzky took of Schwitters that year, were combined during the development process to produce not only a double portrait but also a sort of double-headed one, in which the figures more or less share the same collar and necktie. The portrait to the left shows Schwitters with his mouth agape, standing in front of a collage. Above the black band at the left edge, the collage features a cover fragment from a special issue of Schwitters's avant-garde journal *Merz*, on which both artists collaborated. Below the black band appears a fragment from an advertisement for Pelikan typewriter ribbons, which originally included both the circuitous arrow (now aimed at Schwitters's ear) as well as the ambiguous text that reads "8001?" (the two artists had also collaborated on Pelikan advertising campaigns). The portrait to the right shows Schwitters standing in front of a *Merz* cover, again with mouth agape, but this time his mouth is overlaid with the image of a parrot on a circular perch—playing on Schwitters as mouthpiece of Dada and his propensity to recite phonetic poems.

We might think of Man Ray's "rayographs" as a form of collage, albeit one in which the artist's arrangement of objects is not intended to survive its photographic imprint, just as Man Ray describes destroying his paintings but keeping their reproductions. By contrast, El Lissitzky's *Kurt Schwitters* and Ernst's *The Chinese Nightingale* exemplify two facets of photomontage. The term applies both to prints from multiple negatives, as in *Kurt Schwitters*, and reassembled, cut up photographs, as in the collage version of *The Chinese Nightingale*. But El Lissitzky's photomontage is more than this. Combining two photographic negatives—each of which, in turn, combines photographic portraiture with background "wallpaper" consisting of widely circulated *Merz* covers and a mass-reproduced Pelikan advertisement—it exemplifies photography's thoroughly modern capacity for multiplicity.

10.

BODIES *in*
PIECES

Berlin was the city of tightened stomachers, of mounting, thundering hunger, where hidden rage was transformed into a boundless money lust, and men's minds were concentrating more and more on questions of naked existence.

This struggle for "naked existence," as articulated by Dada chronicler Richard Huelsenbeck, forced Georg Scholz, a wounded veteran, to beg food for his family from a local farmer in 1919. His request was met with a blunt invitation to search through the compost heap. Scholz responded to this encounter with *Farmer Picture* (plate 23), which was prominently exhibited at the 1920 Berlin Dada Fair. The acerbic and gruesome depiction of an agrarian war profiteer, his portly wife, and their devilish son was intended as a scathing critique of hoarding farmers who maintained a comfortable lifestyle amid the economic crisis and food shortages that followed World War I.

To create this incisive social commentary, Scholz wed realistic painting and its traditional concept of a unified illusionistic view with discordant images and texts clipped from magazines and newspapers to unsettling effect. On the far wall of an austere room, above a cabinet graced by a plaster bust of the deposed Kaiser Wilhelm II, hangs a framed image of a red-and-blue-uniformed soldier with a pasted-on photographic face—perhaps that of an older fallen son. (Pasting photographs of lost family members onto standard-issue prints of military men was common practice, and one that, according to Hausmann, shaped the Dadaist strategy of photomontage.) In the left-hand corner, beneath dangling flypaper, sits a heavy sack of grain whose label points to stockpiles of provisions on hand, a reference underscored by the thirty-kilo weight collaged in front. Such sustenance is the preoccupation of the rotund clergyman we see approaching through an open window, the meal he vividly imagines procuring from the family pasted inside his belly. Parked outside, a newfangled threshing machine, presumably cut from a retail catalogue, bespeaks the technological devices by which the modern industrial farmer prospered. On the table a then novel hole puncher and factory-produced porcelain cup, both collaged, and in the foreground a meticulously rendered butter churner, tell of the commodity culture in which this family had the means to participate.

63

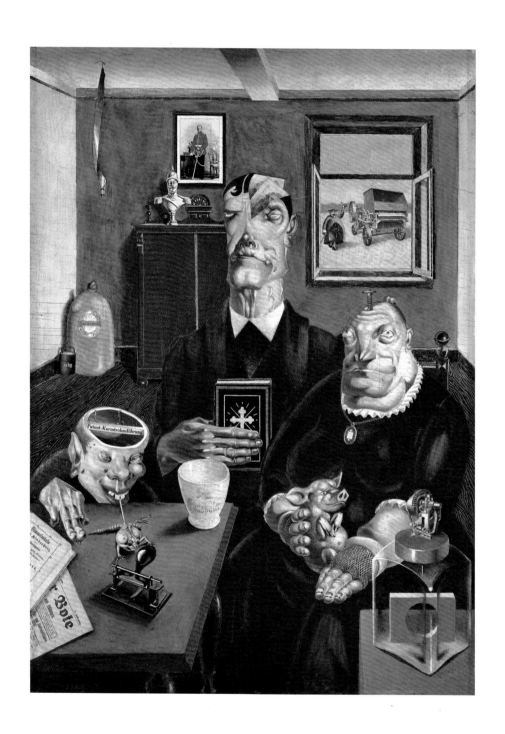

Plate 23
GEORG SCHOLZ. German, 1890–1945
FARMER PICTURE (also known as **INDUSTRIAL FARMERS**). 1920
Oil on wood with collage and photomontage,
38⁹/₁₆ x 27⁹/₁₆" (98 x 70 cm)
Von der Heydt-Museum Wuppertal

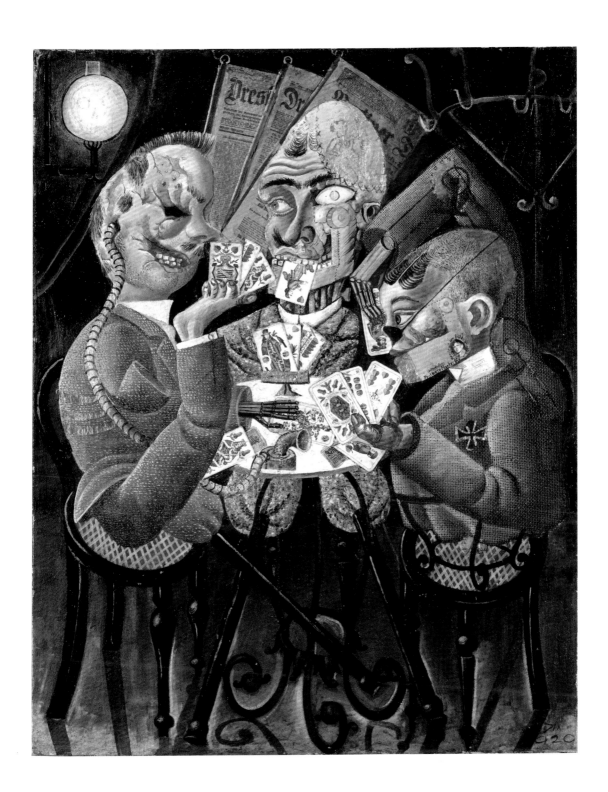

Plate 24
OTTO DIX. German, 1891–1969
SKAT PLAYERS—CARD PLAYING WAR CRIPPLES. 1920
Oil on canvas with photomontage and collage, 43 5/16 x 34 1/4" (110 x 87 cm)
Staatliche Museen zu Berlin, Nationalgalerie

The father rigidly grasps a book of hymns, the hypocrisy of his piety betrayed by the bank notes literally glued on his mind. Coddling a pig as if it were an infant, the mother's priorities are also shown to have run amok, further suggested by the loose screw protruding from her forehead. The pimpled, moronic-looking son perversely torments a toad, his vacant head seen, in cross-section, to reveal a farm machine patent. Below his hand lie a book and a newspaper whose exposed text reads, respectively, "*Himmelswärts*" (heavenward) and "*Kinderherz*" (child's heart), ironically contrasting with words what is represented by the imagery. With meticulous execution Scholz severs, dismembers, indeed mutilates his subjects to convey their perverse predilections.

The strategy of disrupting the continuity of the human form—its sanctity, even—to communicate the diabolical is not without precedent in the history of art, particularly in the northern realist tradition. Scrupulously painted legions of hybrid creatures torment the damned in the "Hell" panel of Hieronymus Bosch's sixteenth-century *Garden of Earthly Delights* (p. 63). Against a background of exploding buildings and armies scurrying through trenches, ill-shaped, misbegotten man, beast, and inanimate object are conflated in a world where order and logic have collapsed. Like Bosch, Scholz presents a preoccupation with sensual and material delights—food, money, machines, indulgences of every sort—that has created, instead of paradise on earth, a living hell.

Many firsthand accounts describe the devastation of World War I—where all known and dependable relations imploded—as apocalyptic. Otto Dix, who volunteered as a machine gunner and served in the German army from 1914 to 1918, wrote, "War is something so animal-like: hunger, lice, slime, these crazy sounds…War was something horrible, but nonetheless something powerful…Under no circumstances could I miss it! It is necessary to see people in this unchained condition in order to know something about man." Painted from personal experience, Dix's *Skat Players—Card Playing War Cripples* (1920, plate 24), combines veristic painting and collage to capture the pervasive presence of war cripples—part flesh, part prosthetics, the nightmarish result of a war fought with advanced weaponry and only rudimentary protection. At a marble table in the curtained back room of a Dresden café, three officers play skat, the national card game of Germany, the actual cards affixed to the painted surface. Typical café accoutrements set the scene: an orb of light illuminates the players from above, and a collage of current newspapers hangs beside a dangerous-looking coat rack placed uncomfortably close to the wounded officers. The prosthetic legs and the furniture legs are indistinguishable from one another. Much more than the officers' limbs have been compromised by the war, as revealed by the contortions to which the men are driven to sit at a table and play cards. The one-armed, blind, and hearing-impaired gentleman on the left holds his cards in his left foot while his mechanical right hand deals. With a glass eye, patched head, and neck and jaw rigged together with a metal strut and a bolt, the officer in the center is reduced to using a card stand and his teeth. (The female form inscribed on his wounded head suggests that his

Plate 25
GEORGE GROSZ. American, born Germany. 1893–1959
"THE CONVICT": MONTEUR JOHN HEARTFIELD AFTER
FRANZ JUNG'S ATTEMPT TO GET HIM UP ON HIS FEET (also known as THE ENGINEER HEARTFIELD). 1920
Watercolor, pencil, cut-and-pasted postcards, and halftone relief on paper, 16 1/2 x 12" (41.9 x 30.5 cm)
The Museum of Modern Art, New York. Gift of A. Conger Goodyear

thoughts are otherwise occupied.) The legless veteran at right, relatively youthful and carefully coiffed, sports a prosthetic jaw to which Dix has added his own passport photo and the inscription, "Lower jaw: prosthesis; brand: Dix. Only genuine with the inventor's picture"—a parody on commercial branding and authentication. The actual playing cards, newspapers, and paper imitation textiles affixed to the painted surface suggest that more than skillful descriptive painting was needed to convey the physical reality of horror.

George Grosz's *"The Convict": Monteur John Heartfield after Franz Jung's Attempt to Get Him Up on His Feet* (also known as *The Engineer Heartfield*) (1920, plate 25) was also informed by personal experience, and, like Scholz's *Farmer Picture*, it was included in the 1920 Berlin Dada Fair. An entry in the Dada Fair's exhibition catalogue described the work: "We see a deformed body, a body whose forms bespeak uncommon reserves of energy, which swell up in every direction against those indifferent walls, the obsession with good food and freedom [...] symbolized by the new home dangling above him, which incorporates a delicatessen." The work's title as published in the Dada Fair's catalogue suggests that this is a portrait of Grosz's friend and fellow artist John Heartfield, whose mental breakdown on the eve of his mobilization to the front confined him to a military hospital for most of his service. We see him in an austere room graced only by a small table and jug, which contrasts with the more ornate view "outside" offered by a portion of a postcard advertisement that is ironically inscribed, "Good luck in [your] new home." His blue smock—with photographic reproductions of cloth mounted on the shoulder and sleeve—simultaneously suggests hospital attire, military uniforms, and the workers coveralls that Heartfield wore in his studio. A delicate yet precise application of watercolor renders his stocky form, clenched fists, protruding jaw, and stubbled chin. The subtle washes of color offset the montaged postcard, fabric swatches, and mechanical heart beating within the artist's chest—a prosthetic device worn like a military decoration. His biliously green complexion indicates livid anger; his body is hemmed in by the cell's confining walls.

While aspects of the image and its title point to the work's subject being Heartfield, it may also be understood as Grosz's own self-portrait—sharing, or literally inhabiting his friend's plight. The use of the word "engineer" (from the German "*monteur*") is a deliberate allusion to industry and assembly-line fabrication—to the act of putting pieces together. Dada artists who employed the technique of combining fragments of photomechanically reproduced images with text and other graphic elements often referred to themselves as "*monteurs*," engineers who assembled and constructed images that incorporated selected bits of the real world to better convey its incomprehensible reality. While Höch and Hausmann (see plate 5 and p. 5, respectively) also used photomontage to create images tightly wed to the historical moment, theirs are chaotic and fractured visions that refuse to cohere into a unified pictorial form. The clipped elements that Grosz, Dix, and Scholz incorporated into otherwise traditionally constructed images invite us into worlds made more painfully vivid by their presence.

MODE DE MON-
TAGE DES DÉ-
FLECTEURS
COURBES, OU
«CASQUE» DU GOUVERNAIL KITCHEN, SUR
LEUR ARBRE VERTICAL DE MANŒUVRE.

11.

exCAVATING dada

In Picabia's *Take Me There* (1919–20, plate 26) and Ernst's *Stratified Rocks. Nature's Gift of Gneiss Lava Iceland Moss....* (1920, plate 27), two signature strategies of Dada are brought together on one stage: using readymade imagery to defy the established order of things. Here technical illustrations, taken from educational publications of their day, are the source of Picabia's and Ernst's imagery. Like so many of the obscure objects and recondite terms favored by Dada artists, a diagram of an automobile quarterlight (or small pivoted window for ventilation, found in older designs of vehicles) published in a 1919 issue of the French magazine *La Science et la Vie* (above) is the inspiration for *Take Me There*. By contrast, Ernst actually drew and painted over an anatomical cross-section of a horse taken from a 1914 volume of the *Bibliotheca Paedagogica*. a teaching-aid catalogue (p. 72), to create *Stratified Rocks*.

Unlike Marcel Duchamp's Readymades, which are uncompromising in declaring their real-world origins, *Take Me There* and *Stratified Rocks* thoroughly transform their applied-science diagrams through the use of fine-art mediums. By far the larger of the two pictures, *Take Me There* preserves the unlikely artistic subject matter of an automobile part while rejecting the cool, no-comment style of draftsmanship associated with technical drawing. Picabia greatly enlarged and simplified the diagram. He also slathered the surface of his picture with oil paint: in addition to black and white (the usual palette of technical illustration), Picabia applied great swaths of red, yellow, and green. The much smaller dimensions of *Stratified Rocks*, by contrast, correspond to the actual page taken from *Bibliotheca Paedagogica*, which supports the artwork not only visually and intellectually, but also physically: Ernst took the anatomical cross-section of a horse, rotated it 180 degrees, then minutely reworked the upturned surface of the diagram with graphite pencil and pastel passages of gouache (an opaque form of watercolor). Whereas the creamy, even unctuous passages of oil paint in *Take Me There*

"Mode de montage des déflecteurs courbes, ou 'casque' du gouvernail Kitchen, sur leur arbre vertical de manouevre."
(Mode of assembly of curved deflectors [automobile quarterlights], or "helmet" of the kitchen helm, on their vertical maneuvering shaft).
La Science et la Vie (Science and life), no. 47
(October–November 1919), Vol. XVI, p. 450

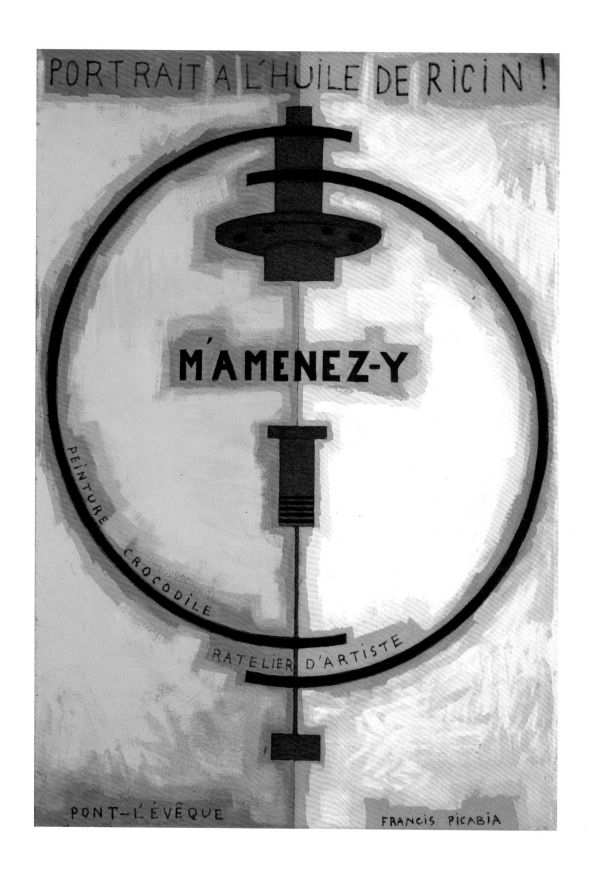

Plate 26
FRANCIS PICABIA. French, 1879–1953
TAKE ME THERE ["M'AMENEZ-Y"]. 1919–20
Oil on cardboard, 50¾ x 35⅜" (129.2 x 89.8 cm)
The Museum of Modern Art, New York. Helena Rubinstein Fund

schichtgestein naturgabe aus gneis lava isländisch moos 2 sorten lungenkraut 2 sorten dammriss herzgewächse b) dasselbe in fein poliertem kästchen etwas teurer

Plate 27
MAX ERNST. French, born Germany. 1891–1976
STRATIFIED ROCKS, NATURE'S GIFT OF GNEISS LAVA ICELAND MOSS.... 1920
Gouache and pencil on chromolithograph mounted on board
with ink inscriptions, 6 x 8 1/8" (15.2 x 20.6 cm)
The Museum of Modern Art, New York. Purchase

Schreibers 5 grosse Wandtafeln „Das Pferd" in halber Lebensgrösse.

contribute to the building up of its imagery, the delicate pencil drawing and gouache over-painting in *Stratified Rocks* subtract as well as add to its underlying imagery. Building right on top of the original image, Ernst causes one surface to disappear even as another emerges. Overall, both Picabia and Ernst delight in subverting the serious work of engineering and anatomy into a form of artistic play, with the notable difference that Ernst, while critiquing the logic and certainties of science, seems to be looking for another (less logical, less certain) form of knowledge, one that forever lurks behind appearances and beneath surfaces.

Picabia was among the great car enthusiasts of his day, and the French phrase that appears in the center of the painting, "*M'amenez-y*" (Take me there), which sounds like "*amnésie*" (amnesia), evokes a sort of Abbott and Costello–like repartee between driver and passenger: "Take me there, Mr. Driver!"; "Where?"; "I forget—Amnesia!" Additional French texts at top and bottom read, "*Portrait à l'huile de ricin!*," "*Pont-L'Évêque*," and the artist's name, "Francis Picabia." "*Portrait à l'huile*" means "oil portrait" (that is, a portrait done in oil paint);

absurdly, "*portrait à l'huile de ricin*" means "castor-oil portrait." (More benign than the visual poison Picabia serves in *The Cacodylic Eye*—see pp. 15–21—here he merely offers a visual emetic.) Like the castor oil at top, another runny comestible is included at bottom: "*Pont-L'Évêque*," a creamy cheese with a soft center named after its home region in north-western France. (If you can swallow—but most likely not digest—the castor-oily picture as a whole, why should you not also be able to spread its creamy cheeselike surface on a cracker or, here, on a board, as appetizer?) Along the bottom segments of the interlocking semicircles that dominate the picture, two additional phrases read "*Peinture crocodile*" and "*Ratelier d'artiste*." The former means "crocodile painting," suggesting oil paint that flows like crocodile tears—which further suggests that painting as a form of personal expression is, like the tears, fake. "*Ratelier d'artiste*" is a clever bit of wordplay on "*atelier d'artiste*" (artist's studio). As slippery as the castor oily/creamy cheeselike surface, "*râtelier*" also means "feed rack" and "false teeth," and, when combined with the word "eating," has the sense of cashing in from all sides (*manger à tous les râteliers*). Together, these

72

Horse anatomy from *Bibliotheca Paedagogica*, 1914, pp. 1056–57

references produce an overwhelming sense of orality while at the same time yielding a sense of falsity to the process to which they all point: the act of oil painting itself. No technical draftsman but no fine artist either, Picabia positively wallows in oil paint and slippery phraseology, reveling in his self-proclaimed status as fakir/oil painter.

In his collage manifesto "A Challenge to Painting" (1930), French Surrealist writer Louis Aragon observed how "The title [...], becoming in Picabia's hands the distant term of a metaphor, with Ernst takes on the proportions of a poem." While Picabia integrates a variety of slapstick phrases right into his picture, Ernst instead places his text below the image, to which it bears an almost uncanny, rather than plainly silly, relationship. Unpunctuated and practically untranslatable from the German, the full title reads, "*Stratified rocks nature's gift of gneiss lava Iceland moss 2 kinds of lungwort 2 kinds of rupture of the perineum growths of the heart b) the same thing in a well-polished little box somewhat more expensive.*" In both the picture and the title, two complementary sets of imagery compete for attention: the first set pertaining to geology, the second, to anatomy. Ernst's geological references include both the earthy prose that we read in the title ("stratified rocks," "gneiss," "lava," "Iceland moss," "lungwort") as well as the stratified view that we see in the picture: layer upon layer of soil and rock surmounted at left by a tan-and-green-striated butte, blue-gray mountains running along the horizon, and at right what looks like a tan volcano belching blue-gray smoke, rising behind a tan mesa. Between the geological imagery on the surface of *Stratified Rocks* and its underlying anatomical imagery, the horse is the turning point. In some sense it might appear quite logical that, once fallen upside down into some tar pit or another, the horse (as dead as any dinosaur) should be trapped and fossilized there; and in turn, rather than conjuring a cowboy in a parched, Wild West landscape (as in the German-language novels of Karl May, as art historian Pepe Karmel observes), Ernst has transformed his faithful horse into the landscape itself. As Aragon describes in "A Challenge to Painting," "[W]ith a bit of color, [and] some sketching, [Ernst] tries to acclimate the specter he has just hurled into an alien landscape [...placing] in the new arrival's hand an object the other cannot touch": a horse that somehow both is, and is not, a landscape beneath which it is buried. But geology and anatomy overlap in other ways as well: In the title, "2 kinds of lungwort" refers to a plant once thought to treat lung disease (the German, "*Lungenkraut,*" literally means "lung plant"); "2 kinds of rupture of the perineum" refers to a rupture in the sinew between the anus and the genitals (the German, "*Dammriss,*" literally means "dam rupture"); and "growths of the heart" is another example of the artist's combination of geology and anatomy (the German, "*Herzgewächse,*" literally means "foliage of the heart").

Ernst recounts his experience of works like *Stratified Rocks* as "a hallucinating succession of contradictory images, of double, triple, and multiple images." In this sense, a desert landscape is simultaneously a dead horse which, following the same plural logic, includes a plant named "lung," a dam made of sinew, and foliage that could be a tumor.

Conjuring multiple images and meanings is the essence not only of the artwork itself but also of its "challenge to painting," as Aragon described it. Traditionally, a picture (Ernst's "well-polished little box") was supposed to be as transparent as a window. Both intellectually and physically, the entire basis of *Stratified Rocks* is its refusal of transparency—the artist has concealed a horse beneath a landscape, after all. As a result, the underlying image is no longer transparent, and painting and drawing are no longer processes limited to the addition of imagery but can also be used to subtract or otherwise modify preexisting imagery. While the experience of a picture does not occur over time (in the sense, say, of a horse galloping across a desert), by rotating the horse 180 degrees before creating the landscape Ernst ensured the impossibility of fully apprehending both images at the same time. Finally, by elevating the title, according to Aragon, "to the proportions of a poem," visual and verbal imagery are so completely imbricated and complementary that neither the one nor the other can be complete and whole in itself.

Published in conjunction with *Dada*, an exhibition organized by the National Gallery of Art, Washington, D.C. (from February 19 to May 14, 2006) and the Centre Pompidou, Paris (from October 5 to January 9, 2006), in collaboration with The Museum of Modern Art, New York (from June 18 to September 11, 2006).

The exhibition is organized by the National Gallery of Art, Washington, D.C., and the Centre Pompidou, Paris, in collaboration with The Museum of Modern Art, New York.

An indemnity has been granted by the Federal Council on the Arts and the Humanities.

This book is a project of the Department of Education of The Museum of Modern art

Produced by the Department of Publications, The Museum of Modern Art, New York

Edited by Cassandra Heliczer
Designed by Amanda Washburn
Production by Elisa Frohlich
Printed and bound by Oceanic Graphic Printing, Inc., China

This book is typset in Avenir, Belwe, Knockout, and Rocktus. The paper is 150 gsm New G-Matt

Published by The Museum of Modern Art
11 West 53 Street
New York, New York 10019
(www.moma.org)

Library of Congress Control Number: 2005935799
ISBN: 087070-705-1

The Introduction and chapters 1, 5, 8, and 10 were written by Sarah Ganz Blythe. Chapters 2, 3, 4, 6, 7, 9, and 11 were written by Edward D. Powers.

Front cover and title page: Detail from Man Ray's *Indestructible Object (or Object to Be Destroyed)*. 1964. See p. 55. Back cover: Max Ernst. *Two Children Are Threatened by a Nightingale*. 1924. See p. 12.

Printed in China

PHOTOGRAPH CREDITS
Bildarchiv Preussischer Kulturbesitz / Art Resource, New York, anonymous photographer, p. 5; Jörg P. Anders, pp. 17, 65; Cameraphoto Arte, Venice / Art Resource, New York, p. 47; CNAC/MNAM/ Dist. Réunion des Musées Nationaux / Art Resource, New York, Georges Meguerdtchian, p. 16; Erich Lessing / Art Resource, New York, p. 64; Digital Imaging Studio, Museum of Modern Art, pp. 38, 41, 58, 60, 61, 69, 73, and Thomas Griesel, p. 67, Kate Keller, pp. 6, 7, 11, 12, 18, 30, 31, 35, 50, 51, 54, 70, Mali Olatunji, pp. 10, 42, 55, and John Wronn pp. 27, 71; Philippe Migeat, pp. 3, 34; Comité Picabia, Paris / D. R., p. 24; courtesy Francis Nauman, p. 48; Philadelphia Museum of Art / Art Resource, New York, pp. 39, 46; Réunion des Musées Nationaux / Art Resource, New York, R. G. Ojeda, p. 22; Roger-Viollet, Paris, p. 25; Scala / Art Resource, New York, p. 9; Smithsonian American Art Museum, Washington, D.C. / Art Resource, New York, p. 49; Tate Gallery, London / Art Resource, New York, p. 5

ACKNOWLEDGMENTS
The authors would like to thank Deborah F. Schwartz, The Edward John Noble Foundation Deputy Director for Education, and Anne Umland, Curator of Painting and Sculpture, for their guidance and support. We are especially grateful to Cassandra Heliczer, Associate Editor, for her editorial creativity and expertise. We are also indebted to Senior Book Designer Amanda Washburn for her thoughtful design, and Associate Production Manager Elisa Frohlich for her astute production. In addition, this project would not have been possible without the generous assistance of Christopher Hudson, Publisher, and David Frankel, Managing Editor, in the Department of Publications, and Pamela Erskine-Loftus, Manager, in the Department of Education. We also thank Adrian Sudhalter, Curatorial Assistant, in the Department of Painting and Sculpture, for sharing her wealth of research.